Of the Land

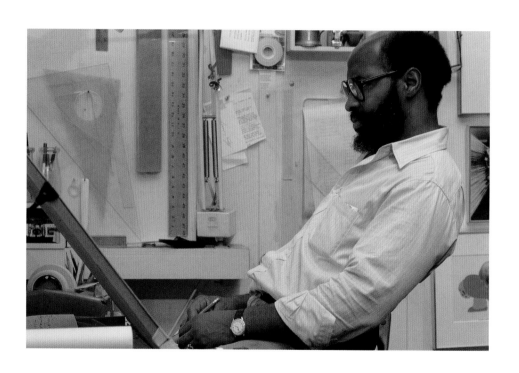

# *Of the Land*

## THE ART AND POETRY OF
# LOU STOVALL

# WILL STOVALL, EDITOR

GEORGETOWN UNIVERSITY PRESS | WASHINGTON, DC

The publisher is not responsible for third-party websites or their content. URL links were active at time of publication. ∞ This paper meets the requirements of ANSI/NISO Z39.48-1992 (Permanence of Paper).

23 22      9 8 7 6 5 4 3 2  First printing

Printed in the United States of America

Cover and interior design by Kaelin Chappell Broaddus
Art photography by John Woo
The photographs on pages xxxvi, xlii, and 92 were taken by Jim Wells
The photographs on pages xii, xxvii, xxxviii, and xliv were taken by Berle Cherney

The publisher wishes to thank Lou Stovall for the inclusion of his artwork and personal photographs throughout this book and Di Stovall for the inclusion of *Hot Dog Woman*. All artists remain the copyright holders of their original works.

Library of Congress Cataloging-in-Publication Data

Names: Stovall, Will, editor.
Title: Of the land : the art and poetry of Lou Stovall / Will Stovall, editor.
Description: Washington, DC : Georgetown University Press, 2022.
Identifiers: LCCN 2021015171 (print) | LCCN 2021015172 (ebook) | ISBN 9781647121716 (hardcover) | ISBN 9781647121709 (ebook)
Subjects: LCSH: Stovall, Lou. | African American prints—20th century. | Prints, American—20th century. | American poetry—African American authors.
Classification: LCC NE2237.5.S76 O4 2022 (print) | LCC NE2237.5.S76 (ebook) | DDC 769/.08996073—dc23
LC record available at https://lccn.loc.gov/2021015171
LC ebook record available at https://lccn.loc.gov/2021015172

# CONTENTS

# FOREWORD

Rolled round in earth's diurnal course,
With rocks, and stones, and trees.
—WILLIAM WORDSWORTH

I must have met Lou Stovall shortly after joining the National Gallery in 2008. He was easy to spot at receptions, a small figure dressed in black (whether it was black tie or not), calm and smiling, Buddha-like amidst the clamor. I was intrigued, and the fact was that his was one of the few Black faces in a sea of white.

I soon learned that Lou was a legend in Washington as well as in the world of printmaking, someone who had worked with such greats as Elizabeth Catlett, Sam Gilliam, and Jacob Lawrence. What he did for his artists, or rather *with* them, was far more than help them make prints. According to his son Will Stovall, whose wonderful essay in this volume is at once a biography of his father and the portrait of an era in the city, Lou was "a collaborator with history." Innovator and proselytizer, he developed ways to recreate (never duplicate) the effects of painting and drawing in the medium of silkscreen, thus elevating a technique that had long been dismissed as a cheap way of cranking out signs (which is where it all began for him as a kid) into something subtle, even poetic.

Later I learned that our families were neighbors in Cleveland Park, and so I made my first visit to the house and studio on Newark Street. Looking around the walls, I discovered yet another Lou, the artist in his own right. My eye was drawn to delicate, craggy scenes of trees, streams, and paths in tondo format, as if seen in a convex mirror or through a porthole. They seemed timeless, beyond style or category. Clearly modern in their abstract designs, they were nonetheless full of detail both finely observed and fantastically imagined. When I heard that these works were to be the focus of this book, I let drop that I could write a few words. Little did I know how much I would learn along the way, or how many dots of my own experience would be connected.

What did I know, after all—a white kid growing up in affluent Bethesda in the mid-sixties and seventies? I heard saxophonist Andrew White blow the roof off of Baird Auditorium, and I was taken with Lloyd McNeill's 1969 album *Asha*, with its collage-like cover signed by the flutist himself. (I still have it.) I probably did not notice the indication on the back: "Graphic design by Stovall Inc., Wash DC." Nor did I notice that White and McNeill, both of whom figure in the pages that follow, were producing their own records. What did I know then about racism and the record industry? Or about artists in Washington who were coming together across genres and racial lines to build culture and community? Or about Howard University, Lou's alma mater, a living link between the Harlem Renaissance and the 1960s? Or about the role of homemade screenprints in getting word of concerts and rallies onto the street? What did I know about making art in a time of convulsion? The protests and riots of 1968 only grazed my neighborhood—touching down at Glen Echo Park—as they only grazed my consciousness. The city was near yet far.

Later, as an art student and then a curator in DC, I would meet Bill Christenberry, Gene Davis, Sam Gilliam, Paul Reed, David Driskell, Sylvia Snowden, and many other artists whose names figure in Will's essay below along with the various circles to which they belonged. Now I see that all these circles met at the M Street Studio in 1968, and Dupont Center from 1969 to 1972, and Newark Street from 1974 until now—all the printmaking studios (which were also listening rooms and literary salons) that Lou and his wife and collaborator, Di, have run for over fifty years.

"The eye is the first circle," declared Ralph Waldo Emerson in 1841. (I hate to stop there, but eye must.) *Circle.* The word and the image are everywhere in these pages, from the wide-angle lens that bends the photographic images of Lou at work in 1974, to the stone path that Lou and Di created around their new home in the same year, to the overlapping cycles of seasons depicted in these poems and pictures. Will's essay takes note of all these circles with a light yet persistent touch, sometimes expanding on the theme: "The first-person, circular format of the prints is an invitation to share in this experience by way of peering through the same set of eyes in a single viewpoint open to all, regardless of individual background or identity." Perhaps the entwined black and white branches of *as Spring Becomes a Leaving* or *In Silent Reach* present an image of racial harmony that Lou not only believed but lived.

Circles run through the poems as well, in their hail of gerunds and participles suggesting ceaseless rhythm and motion (no wonder Lou mentions Gerard Manley Hopkins in his reminiscences): living, loving, knowing, seeing, giving, breathing, singing, greening, beginning, meaning, mouthing, calling, falling, knowing, offering, believing, seeming, coming, sinking, browing, leaving, and (yes) circling. The ongoing-ness of this present tense is captured in a print appropriately titled *time to*

*be*, in which the roots and branches of three trees stretch to the edges of the tondo, like those filaments in a plasma ball that magically respond to our touch. The image implicitly goes round and round, working in any orientation.

Another print I keep coming back to is titled *is bourne of Earth's Sweet Giving*. Unusual in the series, it is divided by a diagonal running like a fault line through the shifted scene. The trees, clouds, and grass on either side are the same yet different—the left half solid and substantial, the right half a grayed ghost. The work is a tour de force, juxtaposing two modes of making, seeing, and feeling, and thus demonstrating the range of effects that can be wrung (in the right hands) through a simple screen. And what of that poetic word *bourne*? It can mean boundary, or goal, or brook. Or is it, punningly, about birth (*born*), or what we have to bear (*borne*)? Once we enter the circle game of these poem-pictures, once we pass through the porthole into the worlds they offer, so replete and yet so welcoming, it is hard to turn back.

—HARRY COOPER

# VISIONS MIRRORED IN A SKY

WILL STOVALL

On Christmas Eve 1973, my father wrote the prelude to "Of the Land":

> What kindness is said
> of loving all living, mine I say, comes
> from the land, and I am enriched by that.

The land he speaks of is a small plot in the Cleveland Park neighborhood of Washington, DC, that my parents moved to in September of that year. Friends and collaborators since 1967, my parents, Lou Stovall and Di Bagley, married in 1971 and, after years working and dreaming, they found their land and began to make a home for themselves.

When they arrived, the house was a veritable jungle. Towers of bamboo surrounded it. The yard was a mess of mud. The previous owners, enclosing themselves in this contained wilderness, let their Great Danes run in the front yard and tear through the mud. In the stone garage in the backyard these owners kept monkeys, parrots, and snakes. My parents arrived in this untamed realm and before anything else, they set up their silkscreen printmaking press and drying racks in the living room of the house. As a housewarming present, friends gave my parents a set of small nautical brass placards that they put over the thresholds of the rooms: the liv-

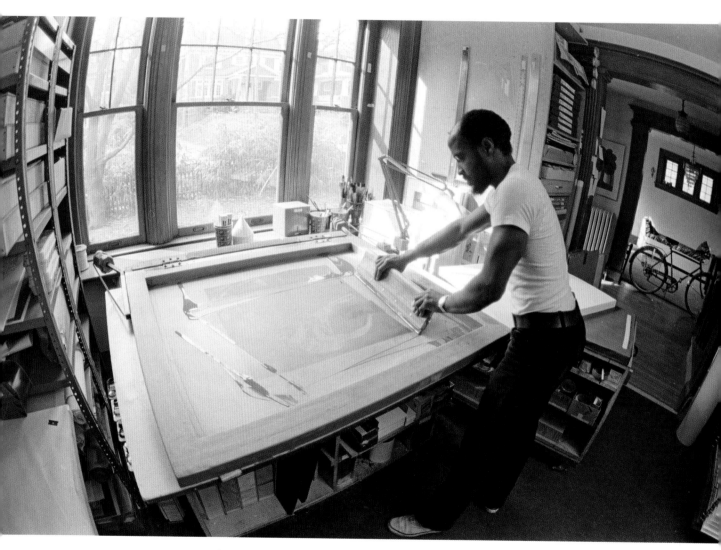

Photo of Lou Stovall printing *an Exanthema of Clouds* in
the living room of the Cleveland Park home, 1974.

ing room, where they printed, was named the Chartroom; the dining room, where they spent their evenings, was the Saloon; and the kitchen, the entryway for many artists, friends, and family over the years, the Galley. In this way, my parents announced that this house was now a vessel with a mission, and they, the residents, were its crew.

With the silkscreen operation set up, on the weekends my parents started to tame the jungle. They cut down the bamboo stalks that lined one side of the yard and, with a whimsical spirit, brought the bamboo in bunches from their private jungle to the National Zoo, where the newly arrived pandas were short on food and happy to receive the gifts. Their wonderful neighbor across the street, Sally Boasberg, an accomplished landscape architect and gardener, had the tip that a Baltimore nursery was going out of business. They all drove out in a U-Haul truck and brought back the magnolia tree, azalea bushes, and boxwoods that are still in my parents' yard. At the driveway, along the slopes of mud that were once a creek, my parents dug out and collected the stones with which they built a path around the house. The path started at the street and led to the front door, each side lined with boxwood bushes. It continued to the right, as you face the house, to the new magnolia tree and past it, and then around the side of the house and back to meet itself again on the left side of the path back to the street. My mom, my dad says, wanted a house she could walk all the way around, like her childhood home in Georgia. It's always a joy to me, walking these intimate paths, watching the birds and listening to their songs. Generations of neighborhood kids have walked the path, exploring it, sensing, I suppose, the spirit of the jungle that was once there.

*Of the Land* traces my parents' first year in the house. The work of the series unfolded over the months of 1974 like the slow building of the pathway around the home, each

vision sprung forth from the home at the center. It was a pivotal year in Washington, DC, too, as the city held its first public election for mayor. My father was thirty-seven years old, the same age as I am now. As I write this I think how much I find myself guided by the philosophy contained in the poetry and art of this series, as I seek to understand what drawing means to me in my work and life.

From winter to spring to summer to fall and winter again, the art in this series revolves around the progression of the natural year. Each day my parents moved further along the path, and each day they were part of the act of making a home in the world—the home where my parents still live today. For me, these works coalesce around two central questions: Where can a person be at home in the world? And how might we all collectively feel at home together?

The drawings and prints and poems began in the winter and look toward a new year, a new spring full of promise, vision, and dreaming. Full of work, creation, and grounding, they interconnect and feed each other, they collaborate and speak to each other. It's a nurturing cycle, without clear beginning or end, except perhaps in the first mark of my father's pen: I can see my father; he looks over the paper, sets down a mark that leads him, and follows that mark. It is a single point with the pen that simultaneously breaks into space and makes space; a mark that fills the space with a vision, so that when we look at it, it pulls us into it.

I draw the way my dad draws, the way I've watched him draw, pushing the pen and guiding the pen across the paper, almost piercing through it, making small marks that reach into another world and seek a vision to bring home in front of the eyes. To draw, in this vein, is to push the mind into new worlds while pulling a new perspective and environment back to the eye.

And yet for my father, at this magical time in 1974, the act of drawing does some-

thing else too: in drawing, his marks combine into something like a guiding rod for song. They are like notes that combine into a melody, for it was in drawing that he would build his poetic themes—giving voice to the images, first silently in his mind before he would then write them out as the poems collected here. I can hear these poems in soft tones when I look closely at the drawings. And so it's like a wonderful feeling of recollection to meditate on the first eight drawings here, as they were before he turned them into the prints and poems, and to then see them large and hear them loud.

In this book, you will see the *Of the Land* series from first conception through its most final state. In part 1, first is the February 1973 "Prelude," a poem that inaugurates the whole series in both its parts. Next comes the poem, "What kindness is said," which introduces the 1974 drawings. Then we have the main theme, "Of the Land," followed by the twelve prints and poems together as my father envisioned them, side-by-side, the title of each print being also a line from the poem, "Of the Land." In part 2, the February 1973 "Prelude" returns to now introduce all seven prints of the second series, completed in 1977, together with three special drawings: visions of new frontiers and the great expanse of life.

    The first print in the *Of the Land* series is called *The Kindness of Living*. It is an emblem of this moment in my father's life. It is the magnolia tree that my parents first planted in spring 1974, which blooms before anything else in their yard and holds its leaves through the summer and fall, giving refuge to the birds that my parents and I still watch from the front porch. This is what *Of the Land* is all about: planting a tree, feeling the tree take root into the soil and become at home, then watching it grow. In my father's print, we feel the roots descend and extend, we feel the leaves sink and

explode into a sea of green. My father's trees spread out to the sky to seek and, at the same time, bring the radiant sun to earth; they bring home what we see so clearly in this first print—the golden halo. He writes in the accompanying poem:

Golden halo, yellow coming
ringing rounds of rolling Spring.
Whispering of willowed wind,
dreaming dreams of everything.

There is a feeling of emergence in the poem, as spring arrives and the tree flourishes and dreams. It expresses presence, a lived-in contentment with being in the world. The three—poem, drawing, and print—play together like melody, harmony, and words in a song. In the drawings, there is the first spark of light. In the poem there is a light you can jump into and feel engulfed by. In the prints, the light expands until it's as big as the sun. Together, they call forward and echo what it is to be in the presence of my dad. You feel the home in yourself grow and expand, which is what my dad invites and encourages. The series is a guide for us all on how to feel at home in the world and how to feel a sense of connection with the past and the future. Altogether the drawings, poems, and prints are a garden made out of the wilderness—and altogether they are a home.

The *Of the Land* series shows my father in midlife in a moment of wonderous awakening. His world, which had grown so large in the previous years, had now found deeper roots. The first-person, circular format of the prints is an invitation to share in this experience by way of peering through the same set of eyes in a single viewpoint open to all, regardless of individual background or identity. My father's eyes opened

wide to see a vision of human life in harmony with nature. It is a view wherein individual life mirrors history, both natural and social, where one can awaken to a world connected through place and time. This feeling of being bound up with history has origins in my dad's first moments in DC.

My father was born in Athens, Georgia, in 1937 and moved to Springfield, Massachusetts, at the age of four. After high school he attended the Rhode Island School of Design for a year before returning to Springfield to support his mother and siblings after his father's death. He came to DC to attend Howard University in 1962 and never left. Immediately upon arriving in DC he was thrown into history.

In "My Story," this book's final chapter, my father writes that at the beginning of his time at Howard, the great James A. Porter—artist and legendary historian of art—drove him and his classmates around the city pointing out buildings and speaking of the architecture, and encouraged my dad and others to learn from all of the wonders they had in this city. This was the beginning of his awakening. And so my dad, who found his purpose and lifelong love of silkscreen printmaking at the age of fifteen, began to learn and study, even as he made posters and prints in his earliest days in DC.

At Howard, Porter was part of an intellectual legacy that began with philosopher of the Harlem Renaissance and Howard professor Alain LeRoy Locke, who emphasized the ability of the Black artist to achieve singular expression and contribute to the world of culture and art. Porter inspired my father to think about the history of African American art and encouraged him to see the world through his own eyes, to make art that reveals his individual spirit, and to pursue individual expression before anything else. Porter also encouraged my dad to open his mind to all traditions, all cultures. My father took these ideas to heart and combined it with his own passion

for existentialism, especially Sartre and Heidegger. My father was starting his search for a vision and wanted to know how he could become an author and artist himself. He was guided by the existentialists' emphasis on individuality and free will, but also looked farther back to Descartes, my father's favorite philosopher. My father taught me about these thinkers and encouraged me to read and study Descartes in particular. To think about the individual viewpoint and our individual capacity to discover truth and to grasp it visually—these are the lessons of Descartes that are so important to my dad and what he has motivated me to explore.

*Of the Land* as a whole was created in response to a Cartesian problem: the question of how to find knowledge and certainty from the confined situation of an individual perspective. My father uses the visual image to demonstrate truth—his truth. The image is founded in a circular geometric form, rooted in the goals of the epoch of evidence beginning with Descartes that a teacher of my own, theorist Rüdiger Campe, describes so well. The works of this series, as in the language of Campe, "double the beholder's gaze" as simultaneously universal and singular[1]—my father's and mine, his and yours, emphatically grounded in the world as an individual presentation before the eyes. The works' circular geometry is like a gateway; it poses a viewpoint filled with spiritual meaning that my father's poetry, in turn, seeks to make vivid, encouraging a feeling of immediate union with something divine.

Without doubt, for my father, for Porter and the community at Howard, Locke's views on the individual are foremost about how an individual is linked to tradition and history and how the individual can seek an inspired collaboration with it—a project very much at home in existentialist philosophy as well, especially Heidegger.

1. Rüdiger Campe, "Shapes and Figures—Geometry and Rhetoric in the Age of Evidence," *Monatshefte* 102, no. 3 (2010): 293.

One sees the importance of knowing tradition in Porter's inaugural book in Black art history, *Modern Negro Art*. It's also reflected in the career of my father's other great mentor, painter and printmaker James Lesesne Wells, another of his professors from Howard and a representative of the Harlem Renaissance. The tradition of the Harlem Renaissance ran deeply through Howard.

Wells emphasized the importance of community—participating in it and building it—and inspired my dad to work in this way. Wells organized workshops to teach printmaking methods with Charles Alston, an artist in Harlem, where great figures like Jacob Lawrence—my dad's hero, with whom he would later make prints—were also students. My father's sense of community continually grew from Howard's richness.

At Howard, David Driskell was a brilliant, young professor of art. Painters Sylvia Snowden, Starmanda Bullock, and Mary Lovelace were classmates. Lovelace's boyfriend and partner, activist Stokely Carmichael, would spend much time with the art students. Lovelace had an incredible energy and Carmichael an intense intellect; they were a wonderful couple. They drew people in, and my dad spent a lot of time with them. At Howard, he continued to make posters, and he made many for the Student Nonviolent Coordinating Committee, known as SNCC, while he was a student. The posters went south to aid in the civil rights demonstrations. They were also used in DC for many famous marches, including the 1963 March on Washington.

My father and his Howard classmates were always making art and discussing politics, writing poetry and reading. When they could, they visited the famous Barnett Aden Gallery, the first Black art gallery in the United States. In the mid-1960s it was in its final years after the death of Alonzo Aden who, together with James Herring, built Howard's art department two decades earlier. They also visited the salons of poet and

Howard professor Sterling A. Brown, where they talked poetry and jazz and were filled with the energy to create, and where my dad and his friends learned how to hold court themselves. And he attended many activist meetings at the apartment of Carmichael and Lovelace near Howard's campus on Fairmont Street. My dad, too, held his share of parties, often cohosted with Snowden and the multitalented Lloyd McNeill, known most as a musician. My dad would collaborate with McNeill, who went on to be an important contributor to the national Black Arts Movement. They made posters for jazz concerts and other events around DC toward the end of the 1960s. As I think about the mix of community, scholarship, activism, and art that my dad and his friends experienced, I think here of Brown's poem the "Odyssey of Big Boy," and his combination of the classical and folk. Big Boy makes his way around the United States, with landscapes seemingly as large as all time and history. In the end he finds a sense of rest and peace, of completion in DC, and in the clarity of life's twilight, calls out:

> Lemme be wid John Henry, steel drivin' man
> Lemme be wid ole Jazzbo;
> Lemme be wid ole Jazzbo....

John Henry and Jazzbo—this union of work and art, might and grace—characterizes the aspirations of my father in his early days. And his stories of this magical time at Howard and its energetic community impressed my older sister Calea—her name an evocation of golden rays—enough that she became a Howard student herself, before going on to become a judge and mother to my two neices, Faith and Grace.

During the 1960s, Washington, DC's art scene was also full of energy and excitement. DC has many well-known art museums, but at this time it also had wonderful

smaller art spaces and galleries, and artists were attracted to the city. It was during this time that the artists who later became known as the Washington Color School were active. Toward the end of my dad's studies at Howard, having distinguished himself as a master printmaker, he was given the opportunity to make a poster for the Josef Albers show at the Washington Gallery of Modern Art, DC's small museum of contemporary art, in 1965, the same year of the museum's influential *Washington Color Artists* exhibit. This wonderful opportunity foretold my dad's future in DC. He would go on to move his studio into the heart of that very same museum and print for the great color field artists of Washington, and through these prints he developed techniques he brought to his mature work, which you see in the prints in this book.

Freshly graduated in 1966, my dad continued his poster making by working at a commercial sign shop. His story is that Harvey Botkin, the owner, didn't want to hire anyone new but finally relented after my dad swept and mopped all the floors one early morning before the owner arrived. "You better hire the kid," everyone said. My dad continued to make posters for Stokely Carmichael in the evening, after finishing work for Botkin. As his friends from Howard spread out into the world, his posters did too. He made posters for early exhibits for artist and musician Lloyd McNeill at Spelman College and for painter Sylvia Snowden at the Delaware State College Museum.

My mom, Di Bagley Stovall, arrived in DC a year later, in 1967, to attend the Corcoran School of Art. My parents lived in the same apartment building, and they met because the doorman of the building, a big personality and friend of my dad's, hosted a party with my dad for all the young art students and artists that he knew. My dad and my mom met at that party, and right away they started to work together mak-

ing posters. At first Botkin was unwilling to hire a "young girl," but once he saw how well my mom, who was always calm and ready for adventure, handled a truck, he was convinced.

My mom was born in Columbus, Georgia. Her father was a judge and veteran who had served on D-Day, and her mother was a nurse. My mom was the youngest of three, and she would play on the courthouse steps where her father worked. He was a wry man given to solemnity if not somber episodes but had a great love of people and justice. He conducted weddings in his living room for couples who couldn't publicly marry, in the name of justice. My mom has always carried her love of Columbus with her, and she had a great friendship with the painter Alma Thomas, who also grew up there. When Thomas would see my mom at DC parties, she would shout out "Columbus!"

In fall 1967 President Lyndon Johnson appointed Walter E. Washington as the first mayor of DC. There was a growing civic energy spreading through the city in the wake of the civil rights victories in the South. New organizations were popping up around the city in response. There was Gaston Neal and Don Freeman's New School for African American Thought and Liberation, which brought Black art, artists, and performers to DC, and Topper Carew's New Thing Center for Art and Architecture, an important arts center in the Adams Morgan neighborhood. The young future mayor Marion Barry, visible in DC for the first time, started Youth Pride Inc., his influential job placement program for African American youth. This energy was fusing with another kind of civic energy. DC citizens were still not allowed to vote for their own leader at that time, and the citizens were growing tired of being disenfranchised and a new movement was stirring.

Excellence in Education can be achieved only when a community values education as a precious goal and has the power and resources to manage its own schools.

Charles I. Cassell campaign for the 1968 Washington, DC, School Board election.

Lloyd McNeill was newly back from Paris where he studied at Beaux-Arts de Paris and performed with fellow Howard graduate and saxophonist Andrew White, a legend who would later tour with Stevie Wonder. In France, McNeill befriended Pablo Picasso, even living with him for a time. Together Lloyd, my dad, and my mom started making posters for this burgeoning city movement. With a twist on Picasso's cubism and incorporating the discourses of African art from Howard, Lloyd made abstract figural compositions in the mode of the jazz improviser that he was by tearing tissue paper that my dad cut in silkscreen film, organizing the image and making his own hand-cut lettering. It was a new way to think about silkscreen composition and an exciting collaboration. Together with my mom, the group made posters for many new organizations and jumped into the events around the city. They made posters for the New Thing and Youth Pride Inc., among others. They also made posters for musicians—some were local, like White and the rising star Roberta Flack, a friend from Howard—and some were national celebrities, like jazz guitarist Wes Montgomery and Miles Davis, who performed at DC's Bohemian Caverns jazz club under the auspices of the club's impresario, local legend Tony Taylor. They even made a poster for the first public election in DC, the hotly contested November 1968 school board election. All other offices were under appointment by the federal government, so this election took on a bigger importance. Howard was never far from my father's thoughts, though. He made the poster, booklet, and meal card for the important Howard Black University conference in November 1968, an outcome of the Howard sit-ins from the previous spring led by Tony Gittens and others, which gave rise to many of the Black studies departments in US universities. I always pause to remember that sometimes they printed five thousand copies in one go, each one by hand.

―――――――――

In 1967 and 1968 my parents were often at the Dupont Circle fountain in the evenings where, after long printing sessions, they would join with friends and hand out posters for the Tuesday night concerts at the New Thing. They talked and played music and walked to the restaurants in Adams Morgan and the jazz clubs on U Street. In the process they befriended Walter Hopps. An influential curator and museum director, Hopps founded the Ferus Gallery in Los Angeles in the 1950s, which launched the LA art scene and started the careers of many artists we all know today. He was one of the first to exhibit Marcel Duchamp and Joseph Cornell. It was a scene of great fun that in many ways centered around Dupont Circle and its adjacent neighborhoods. Lloyd McNeill and Hopps lived near each other at the bottom of Eighteenth Street in Adams Morgan, and my parents lived a few blocks east of Dupont Circle off Massachusetts Avenue. It was a community in art and in life.

In January 1968 the Washington Gallery of Modern Art (WGMA) was in hardship. Hopps came to DC from LA to work at the Institute for Policy Studies as a fellow and to study the role of the museum in public life. Author and philanthropist Phil Stern was on its board and his wife, artist Leni Stern, was chair of the WGMA. She invited Hopps to compose a five-page prospectus for the future of the museum. After reading it, she was convinced he was the one to lead the museum in its final year and to create the bridge between it and the Corcoran Gallery of Art and its school, into which the WGMA was to be folded. Hopps would later go on to be director of the Corcoran. And he mounted the WGMA's three last shows. Each was challenging but hugely popular in DC. One was the work of LA artist Noah Purifoy, who cofounded the Watts Towers Art Center . The second was the famous installation artist Ed Kienholz, Hopps's friend and partner with whom he started Ferus Gallery in LA. The last

solo show before this transition was the work of Lloyd McNeill, who in the same year had one of the last shows of the Barnett Aden Gallery. Lloyd's exhibition was called *Intercourse*, which shocked the WGMA board members aside from Leni, who was an adventurer by heart and loved everything exciting. My parents worked on the installation, printing the exhibition poster and organizing various events and happenings. Jazz pianist Herbie Hancock performed, among other famous musicians, over the show's month-long run. It brought people of all walks of life into the museum, a previously stodgy institution without much diversity in its crowds.

My mom has stories of setting up the top floor installation of McNeill's exhibit while the Kienholz pieces, in their haunting beauty, were still partially there because they were so hard to de-install. They worked through the nights amid the stirring presence of the Kienholz fragments as they transformed the museum into the carnival of art, music, and poetry that would soon be McNeill's *Intercourse* exhibition.

My parents became close friends with Hopps and, in the course of building the show, even closer with Phil and Leni Stern. The Sterns were wonderful spirits and together they authored a great book on the problem of poverty. They had a keen sense of justice and wanted to make an impact on culture and individuals and to build links between people. Impressed with all that my parents were doing in community poster printing, they gave my dad his first grant. With the investment, he bought a much-needed professional drying rack for silkscreen prints and rented a studio on M Street in Foggy Bottom. The studio space was on the edge of DC's arts district of the time—a golden age for art in the city—just a few blocks away on P Street from Dupont Circle, where you could find the WGMA as well as the famous galleries of the day, the Jefferson Place Gallery, Henri Gallery, and Phillips Collection, the first museum of modern art in the United States.

My parents set up the M Street studio in late spring of 1968, just as DC was reeling from the assassination of Martin Luther King Jr. and just as Resurrection City was being built on the National Mall as part of the Poor People's Campaign—an economic justice effort in the United States, which was organized in part by future Cleveland Park neighbors and friends, Marian Wright Edelman and Peter Edelman, important activists and aids to Robert F. Kennedy. Amid all of this, my parents were able to build something from the sadness and horror of those days to create a chance to gather the local spirit into something fresh and new. They attracted visitors and guests daily. Their studio was a great haunt in the city for people looking to see something budding from within the ashes. Through this spirit, they started making posters for the Summer in the Parks events of 1968. The program called for an end of violence and fostered a chance for reconciliation through a series of summer-long events and concerts that brought the people of DC together in National Parks spaces around the city.

During this same period of time, Walter Hopps was at work transforming the Washington Gallery of Modern Art into the experimental annex of the Corcoran. He proposed to the board that it be a museum with a gallery space that would also be home to artists of all traditions, a renaissance vision of an integrated artists workshop. His idea updated and echoed the Washington Workshop Center of the Arts from the earlier generation, which provided classes, exhibit space, and a community for artists and birthed the Washington Color School. Hopps's vision honored the youth culture and spirit of the 1960s as well as its love of improvisation and connection. Connection and interchange between the arts and artists is what he wanted. In fall 1969 Hopps invited my parents to move into and run the new Corcoran annex called the

Tony Taylor with
Di and Lou Stovall
outside the Dupont
Center in 1971.

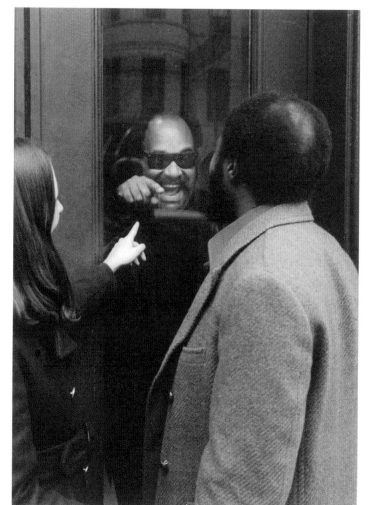

Dupont Center, giving my father and his printmaking operation pride of place in its center. To underscore that a great advance in the art world was taking place, Hopps simultaneously organized the now-famous *Gilliam, Krebs, McGowin* exhibit at the Corcoran, where Sam Gilliam, the youngest of the Washington Color School artists, first presented his drape paintings to museum audiences.

My dad's studio was on the second floor, the heart of the museum and, in Hopps's renaissance vision, he represented printmaking. The first floor remained a gallery space. My dad ran the Dupont Center, while Hopps was director at the Corcoran. Photographers Mark Power, Joe Cameron, John Gossage, and Allen Appel were on the third floor. With the remaining money from the Stern grant, my dad bought a table saw for woodworking and put it in the center's basement. A few blocks away, Gilliam and Rockne Krebs shared a studio at Johnson Alley. Sam, continuing the renaissance theme, represented painting, and Krebs, sculpture. In their studio, these artists fed off of one another, and that energy led to the creation of many powerful works. In fact, Sam's early famous beveled-edge paintings—an outcome of the interchange between Krebs and Gilliam—were built there.

Dupont Center quickly grew into the space that Hopps had envisioned. There was a constant stream of students and artists and guests. Photographer William Christenberry was professor at the Corcoran, as were painters Paul Reed and Gene Davis, and they would visit and connect. Black and white, young and old, male and female, artists and politicians—all came together in this space that Hopps made possible. Katharine Graham, publisher of the *Washington Post*, visited, as did one of the *Post*'s most famous editors, Ben Bradlee. Each bought prints from my dad for their offices and the newsroom, which you can even see in the background of the movie *All the President's Men*. Behind Dustin Hoffman and Robert Redford, playing the famous

journalistic duo Bob Woodward and Carl Bernstein, you will see them on the walls. Hopps, ever the maverick, would hide out at Dupont Center during the day, infusing new ideas into the energy of the place. As the Corcoran's director, people would look for him at the gallery and never knew where to find him. This led to my dad printing the infamous button, "Walter Hopps will be there in 20 min," an inside art-world joke all over DC.

This was a prolific time for my dad. There was such energy in the daily visits, opportunities for experimentation, and so many artists to connect with. There were exhibitions inside and outside. My father constructed a giant double-sided mobile silkscreen unit that allowed six people to print at a time, bringing the energy and dynamism of his studio out to the streets. Dupont Center signaled the beginning of my dad's work on fine art print editions. These works were collaborations between him and other artists, either to recreate one of their works in a silkscreen medium or to create something completely new—a true collaboration. It began with Paul Reed and then Gene Davis. Thomas Downing and Sam Gilliam followed. The color field artists were attracted to my dad's techniques, especially silkscreen's ability to present the perfect alignment of geometric forms. It's something that moved Reed to muse in a 1969 *Washington Star* article on the Dupont Center scene whether silkscreen printing is indeed more adept to the color field idea than even acrylic painting. Other luminaries of the city came, too, such as the elder artist and curator Jacob Kainen, who wrote an article for the *Washington Post* on silkscreen collecting in DC with special mention of my dad. He oversaw the first acquisition of my parents' posters for the Smithsonian American Art Museum.

The artist Jeff Donaldson came to DC in 1970 to be chair of Howard's art department after his important work in Chicago to help found AfriCOBRA, a true avant-garde movement. Donaldson, suspicious of old establishment art, was attracted

to the new techniques in screenprinting that my dad was exploring and they began a collaboration. Donaldson relished in the athleticism and loved how my dad climbed on the silkscreen table, resting on a plank, to paint out his cut stencils with the unique screen filler solution that my dad developed to make dynamic and explosive prints.

At this time, not satisfied with using the traditional cutting instruments, my dad was experimenting with a diluted screen filler solution, a combination of lacquer thinner and castor oil he developed. Harnessing the spirit of innovation and performance, my dad deployed these new techniques in the service of early visions of natural harmony and utopia. The prints my dad worked on while at Dupont Center were explosive abstract landscapes, visions of what was soon to come in the *Of the Land* series.

Always committed to the communal, my dad shared these same techniques in his collaborations with the community. You see them used in Donaldson's much-loved *Victory* print, a collaboration with my dad, which has now traveled the world as part of the Tate Modern's *Soul of a Nation* exhibit. Gilliam's *Dance*, the first of the twenty-one prints the two would create together over their over fifty years of friendship and collaboration, uses these techniques as well. And my mother's *Hot Dog Woman*, part of the *Washington Post* collection and exhibited at the Phillips Collection in 1972 along with an early landscape diptych by my dad, included at the end of this book, also used this same method.

During this period of the late 1960s and early 1970s, DC was beginning to really engage with and push back against the influence of the federal government in its self-government. The federal government often acted as though it forgot there even was a local community here. These were the beginnings of the Home Rule move-

Di Stovall, *Hot Dog Woman*, silkscreen print, 1972.

ment. As the local focus grew, interest by federal government programs in my parents' work increased. The Peace Corps, AmeriCorps VISTA, Job Corps, and the new Lyndon B. Johnson programs oriented to a social safety net all requested posters. And my parents were the perfect spokespeople for this new change, putting their voices into the posters of these campaigns with phrases like, "Job Corps—can you dig it?" After all, work and harmony was their message and they wanted it to be loud and clear.

The 1970 Love Parade was a great example of how big my parents' voices had grown. It was a parade imagined by my dad to honor and celebrate love. The parade started at the Dupont Center workshop at 1503 Twenty-First Street NW and went down to the Corcoran Gallery on Seventeenth Street NW by the White House. From local to federal, it included performances and music and even a mass wedding. It was a triumph of love and of the rights of people in the city, celebrating the people's win in the controversial Three Sisters Bridge project, which had just been struck down a couple of months earlier. The proposed bridge had threatened to strangle local streets and neighborhoods in service of new interstate highways cutting through the city. The people felt alive in DC and the new spirit was open to all. And love did triumph. My parents were married the next year. Phil Stern was my father's usher, and Paul Reed, my mom's—in honor of the forces of love and civic spirit, art and city that brought my parents together.

In time, the Corcoran Gallery decided to restructure, and after three years of innovation and fun, performance, and exhibition the Dupont Center closed at the end of 1972. The photographers at the Dupont Center moved their studios to the Corcoran. Sam Gilliam and Rockne Krebs moved their studios to Jefferson Place off of U Street (beating out politician and activist Marion Barry for the space), and my parents tem-

porarily moved into the Kalorama neighborhood home of Phil and Leni Stern, as they figured out what's next.

My father moved his silkscreen press, drying racks, and equipment to the Stern's home. During the day they continued to print. They created *Signal*, a fantastic print for Gene Davis in honor of the new television station tower in Tenleytown, rising above Northwest DC. They made a series of three prints for the famous abstract artist Robert Mangold and another set of ten prints for the Equal Employment Opportunity program, featuring collaborations with Gilliam and William Christenberry, together with prints by my mom and dad, and Lloyd McNeill, too.

Their year at the Stern's was also a chance for quiet and a pause. And reflection. In the evenings, my parents ate dinner and dreamed of a home of their own. They read poetry and played music and, most importantly, they drew. They sat on the floor at a short Formica-topped table that my father built. They drew and made plans and dreamed of making a home together. My parents, newly married, were deep in love, and my father began making drawings in the circular format, each a vision, each with the dedication to love, "For Di," my mother.

In February 1973 my father captured his mood in a poem:

> . . . at a time in life—
> when Living and Loving
> is one act of kindness.

This became the first prelude to the complete *Of the Land*, the first series and the second, and it appears first. It is this writing that is the seed that they would plant in Cleveland Park seven months later.

As a kid I remember asking my dad whether he believed angels are real. He told me, Yes. Shocked, I said, Really? And he said, Yes, I believe there are people so good

they have to be angels. This is how my dad must have felt while he was drawing and dreaming and writing words of kindness. He was alive and he was in love, and life for him was kindness.

One angel that came to my parents was journalist and organizer Sam Smith. He organized on behalf of DC Home Rule and the DC Statehood Party, a movement my dad, a committed Washingtonian, believed in greatly. Sam invited my parents to his home where he held cookouts on his front porch overlooking the quiet tree-lined street where he lived in Cleveland Park with his wife, Kathy, and two sons. He was a big spirit filled with gusto and verve. As my parents walked up to his house, he'd shout out to them from his porch. Kathy, a wonderful advocate for DC and a historian of neighborhoods, was a great friend to my parents too. In the spring and summer of 1973, my parents spent weekend afternoons with the Smiths, talking and eating together on their big front porch. All the while, my parents would look over and keep an eye on this curious, neglected small stone house in a jungle of bamboo and mud.

My parents had dreamed of a home of their own for so long that they could not pass up the opportunity of this newly vacant house. First they rented it, posing to the owner the vision to renovate the home and yard in exchange for some reduction in rent. The owner accepted, and eventually my parents were able to buy the house too. And that's how it happened. In the effort of working for DC Home Rule, itself an effort to make a home for DC in the nation, my parents found their home next door to the Smiths. The story is so simple, but it changed everything for my parents.

Working and being at home was something my parents loved, and they were so happy. Busy night and day, my dad began printing the first print for *Of the Land* over

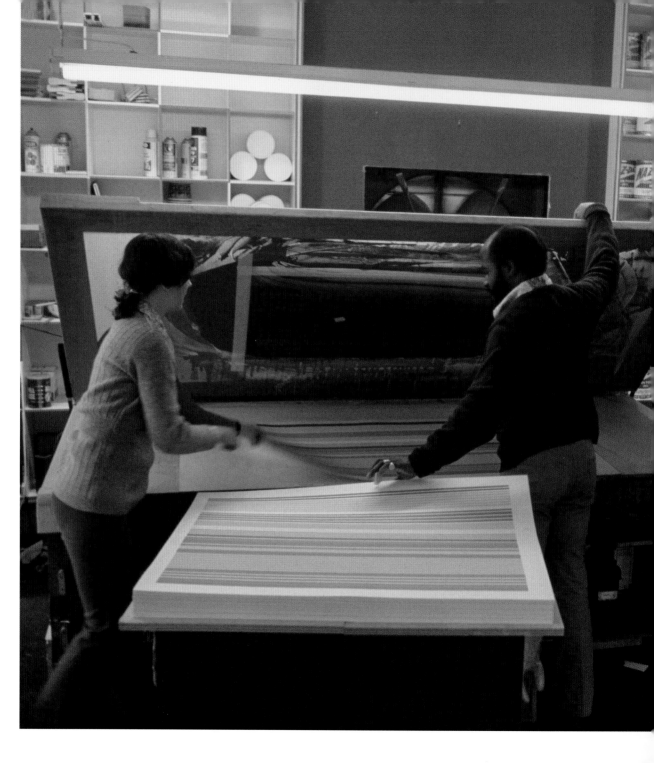

Lou and Di Stovall printing
Gene Davis's "Signal" at Phil and
Leni Stern's home on S Street
in Kalorama, 1973.

the winter holidays, 1973 and into 1974, writing out its theme on Christmas Eve. This theme would become the prelude to the first series of *Of the Land*:

> What kindness is said
> of loving all living.
> Mine I say, comes
> from the land, and I
> am enriched by that.

As he wrote this, he set about to live it and bring his visions into the world, all while continuing to write. First he created the drawings, 12 jewel-like, intimate pieces. He gave my mom 8 of the drawings to keep and protect, which she still does. He wanted to share the prints, however, with everyone. He made 60 prints of each of the 12 prints of the editions—a total of 720 prints—and priced them just to cover his costs. I see them today all over Washington in collections of friends, and I love them all.

Through the years at Dupont Center and before, my dad honed his technique, deploying his new innovations in painting on the overside of the silkscreen to make subtle changes in tone and gradation; painting over cut stencils in succession, each stencil adapted for a change in tone or shade. In the *Of the Land* prints, he harnessed all that he had discovered in pursuit of these visions, this utopia.

My dad pursued fidelity to the natural world, a vision of nature infused with spirituality and a desire for perfect harmony between humanity and nature. His search for utopia was part of an exploration he began early in his life and continued as together he and my mom built their home, laying its path and living through the seasons. And, indeed, there was victory in the air. By May 1974 DC was awarded its city charter, which allowed the District to govern itself locally. In November its residents

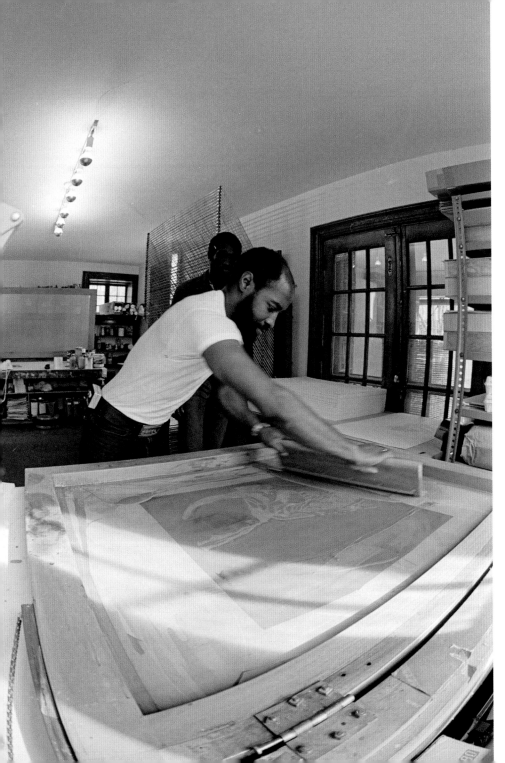

Lou Stovall printing *an Exanthema of Clouds* in the living room of his Cleveland Park home, 1974.

were able to vote for its mayor for the first time in over a hundred years. And again, my parents tell me, they were so happy. The new home gave my parents space and freedom in which to work. The result at the end of 1974 was a catalog of connected prints, drawings, and poems that spanned the months and traced the seasons as they rooted themselves into the land and earth. Together these comprise the first part of the *Of the Land* series and are the first works in this book.

The title of each print is a line from the central poem, "Of the Land." The poem, in turn, reflects the natural course of the year:

> the Kindness of Living
> amidst Love's Greening Land
> is bourne of Earth's Sweet Giving
> of Morning and Evening and Seasons.
>
> and Knowing of this Believing
> seeing now the Coming Yield—
> break from Heaven's Great Being
> an Exanthema of Clouds.
>
> as Spring Becomes a Leaving
> and Summer's Spirit Holds Love's Stay
> the Bounty thus is Falling
> and Winter's bear the Promise.

Each print with its accompanying poem is about the nourishment my father receives from the earth. My dad writes of "Earth's Sweet Giving," and he writes of "Bounty." He writes of all the gifts he received and for which he felt such gratitude. This catalog of prints and poems is meant to give and inspire a feeling of this giving, to express

a moment of active and continuous nourishing. The language of the poetry extends through all the seasons—*greening, knowing, seeing,* and then *leaving* and *falling,* which cycle back to *living* again and *giving* again.

In this bounty, in the late summer of 1974, with the garden path reaching completion around the home and the print cycle nearing its end, my parents started to build a studio in the backyard. They chased out the thousands of crickets, the remaining guests of that strange backyard zoo from years before. They cut the wood on the trusty table saw my dad bought while at the Dupont Center, and, with his friends, he built a studio that was attached to the garage, mirroring the roof's style and doubling the structure in size. This was the new studio, the new workshop, which inspired Sam Gilliam to later write: "To see how nature is distilled into the art of printmaking, come to the Workshop, through the garden, behind the badminton court. Here a magician works from the world that we are in, into an art world."[2]

In the new workshop, my dad built a much larger screen table for his work—his largest—and another one for students. The screen tables faced each other and opened up like two wings. Behind his screen table, over his right shoulder and over a shelf of his handmade printing tools, my dad hung the familiar portrait of Professor James Porter, donning a cap with his friendly and immensely intelligent eyes. This portrait faced his students, so they would be sure to notice. Across the room from my dad, hung so he could see them, was a collection of antique tools that my mom's brother—a natural collector who had a great bond with my dad—gave as gifts to the new studio. These tools were testaments to the craftsmanship of silkscreen as well as tributes to the early canonical figures in Porter's *Modern Negro Art*, the spirit of the ar-

2. Quoted in *Lou Stovall: The Art of Silkscreen Printing* (Washington, DC: Howard University Gallery of Art, 2001), exhibition catalog.

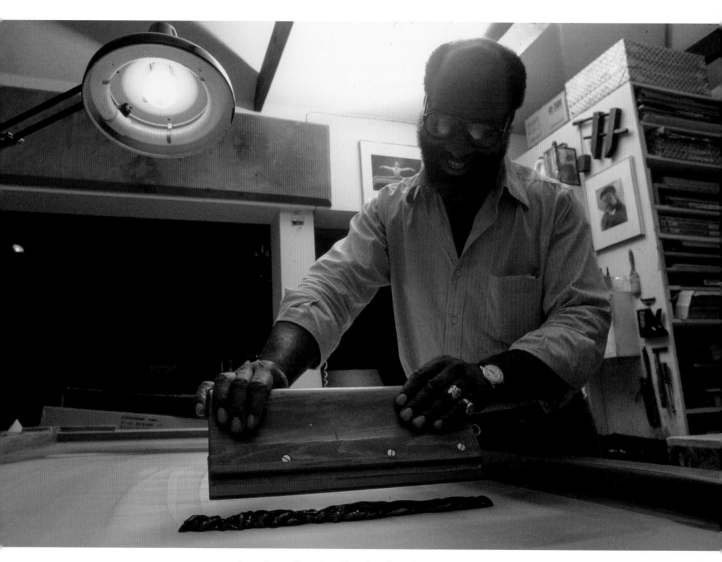

Lou Stovall in the Cleveland Park studio, 1975.

tisan at the origins of art history. These items remained in the studio all while my dad worked in it.

In the studio, my parents also hung the same pictures they had on their studio walls years before, adding more art of their own and art from friends. My dad hung his first print, the Josef Albers poster he had made for the Washington Gallery of Modern Art show in 1965, like a trophy. This print, which my dad made as a young student, was a signal of what hard work can bring. Only four years later he would work and operate the museum himself, all in the name of silkscreen as an art. My parents hung photos of friends too. And they hung one of my favorite photos: my dad and mom and Afghan dog, Ruby, posing with friends—the friends who would later help build the new studio—while taking a break from working on the *Of the Land* prints in the living room.

The table saw was always buzzing, and my dad would make a new piece of furniture for the home every year. My mom would often paint the new pieces and make other decorative work of her own, homages to gardens and scenes of nature, in addition to her own prints and paintings. The Formica-topped modernist furniture was paired with organic and sinewy wooden forms, evoking nature too. My parents were bringing their visions of gardens indoors.

With all the silkscreen equipment now moved to the studio in back, they were able to add photos of nature to the art that covered the living room walls. Friends from the Dupont Center, Mark Power and William Christenberry, now a neighbor, gave them photos in honor of friendship. They also acquired photos by the grandfather of photo collecting, Harry Lunn, who spent many days at the old Dupont Center before moving to New York and then Paris. In my dad's collection of photos, images of local nature combined with photos of natural beauty from California, Mexico,

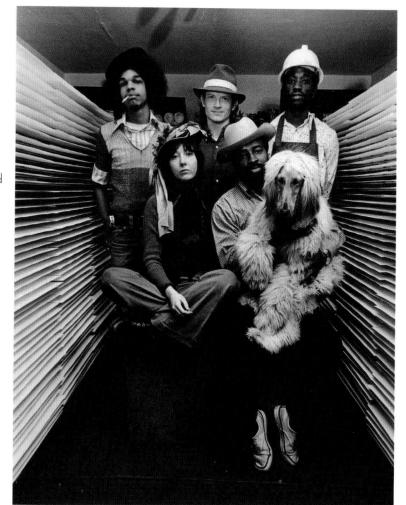

Ro Thompson,
Di Stovall, David
Bronson, Lou
Stovall, Ruby
(dog), and Ed
Banks, 1974.

France, and Tanzania. For him, his view of the world was expanding while his home was coming together. And all the photos had to have trees. It was as if after the printing the *Of the Land* series with its views of nature, the living room could only have similar natural visions on its walls. It had to be a garden itself.

Soon all the energy of the earlier years downtown came to Cleveland Park. The house was open to all their friends. It was smaller and lower than its neighbors, friendly and inviting, in the mood of my parents themselves. Sam Smith would still call neighbors onto his porch and my parents would invite neighborhood kids to their yard. On weekends they would cook out, play badminton, and swim in the pool across the street at the home of Sally and Tersh Boasberg. The whole neighborhood was like a village, with troops of neighborhood kids at play—the children of the Smiths, the Boasbergs, and later Marian Wright Edelman and Peter Edelman, who all would be instructed in the powers of silkscreen printing. Tersh still visits with my parents on his daily walks.

    Inside the house there was a constant stream of activity. Sam Clayton of the band Little Feat would come, and Bonnie Raitt, Stephen Stills, and other musicians visited as guests of their concert promoter friend, Mike Schreibman, and of *Washington Post* critic, Richard Harrington. Renato Danese, the curator at the Baltimore Museum of Art and later gallerist, lived for a time on the third floor on the weekends. And Kathleen Ewing, an important supporter, visited often. My parents had parties and games, but these were interludes between long stretches of work. Music, from jazz to rock to opera, was always playing while they printed, and visitors were happy to jump into the work and participate in the process. They passed blank paper to my dad who, in his grand sweeping movement, pushed ink through the silk with

his squeegee, laying down rich and succulent swaths of oil-based ink. Friends then passed the printed sheets to the drying racks, rejoining the party before it was time to print again. The photographers of Dupont Center came to use the mat cutter and table saw. Many students came to make frames and learn to frame, which continued on for decades in the studio, parallel to the printing. Everyone knew that at 4:00 p.m. my dad and mom would break for cakes and tea. Music was always on and the phone was always ringing—people called as often for my parents as for others. They called looking for Sam Gilliam, ever in pursuit of the next great feat and marvel, or Walter Hopps, director at the time of the National Collection of Fine Arts, now the Smithsonian American Art Museum, constantly sowing seeds of ideas around DC. Others would come over too—like William Christenberry, who lived a few blocks away, and Gene Davis, also a neighbor. They would sit at the green table in the kitchen that my dad built for my mom when he lost a bet on the 1973 Kentucky Derby.

Sometimes the visits continued throughout the night, friends never leaving, as my father was known to work to the early morning. The famous innovator of color photography, William Eggleston, up from Tennessee, would often visit his longtime friend Christenberry and afterward would walk (or more often drive) the two blocks to my parents' house at night to check in. He would chat from outside the studio door while my dad worked, but more often he played badminton or had a nightcap with itinerant artist Larry Starks, who lived for a time in a van in my parents' driveway. People came in and out bringing their own unique visions and ways of seeing the world. On one day, on his way to the bathroom, my dad saw Ruby, my parents' Afghan dog on her dog bed. Because he was inspired by how perfectly the dog posed, he ran down and got John Gossage, who he knew would photograph her best. The photo still hangs in the bathroom of my parents' home in honor of the charming moment.

Indeed, everyone loved Ruby, who perhaps embodied some of the magic from the old bygone wilderness. Gilliam dedicated one of the first of his white paintings from the mid-1970s, called *Rubiyat,* to her. The spirit of the Dupont Center wrapped around them on a stage of their own with an even more intimate connection between art and love, city and friendship. They continued to print posters for events and causes, even as their collaborations with artists on fine art prints grew. They were not ready to let the spirit of the Love Parade and other events die away. In the evenings, my parents still drew together, something they continued though the years, and which I eventually joined too.

The final works in this book, in part 2, comprise the second series in the *Of the Land* series. From 1977, they reflect the spirit of the time—both local and federal DC were looking ahead to a promising future. The Metro, DC's subway system, was a year old and now linked my parents' neighborhood, Cleveland Park, with downtown—connecting the city with the nation. The bicentennial in 1976, the year before, confirmed that the American experiment had staying power, and its celebration brought more people to the National Mall than ever before. The newly opened National Air and Space Museum, too, reflected the future and new frontiers. And for my parents, life was settled and the future an open horizon. They celebrated this new chapter by taking a trip out West to visit my mom's sister and her family. With drawing kits in hand, they visited Mount Rainier and drove further, going as far as Banff, Alberta, in Canada. They stopped to draw whenever they were inspired by something beautiful.

When they returned from this trip, my father celebrated his fortieth birthday and began the second part of the series. This second part of *Of the Land* revisits the first twelve prints in the series and pays tribute to all of the printmaking tech-

niques he had learned and how he had grown since creating them in 1974. Printed on the larger screen table in the new studio, these prints are bigger than those in the first series and more explosive. They capture the same theme of rooting and reaching but have even more force and energy, expand even further into the sky and the world. They carry the energy and promise of an artist who, at forty, still had so much work to do. Today, at eighty-four, he is still working. He works in collage in the dining room—still with its placard, the Saloon—where he made his first early drawings from the series with my mother. He's in love with life and living, cherishing this home that he found, and honoring nature and the land.

These larger prints don't have an accompanying poem, but visually they sing a song of a great journey that, like life itself, continues on and will continue and must continue. Their message to me is to affirm that you, your path, are good; you are protected, secure, and not alone. These works reflect that we, in witness and in collaboration with nature, are a part of a larger whole. They teach me beauty, where having lived and living are part of the same moment, in the same moment of cocreation and being, the same image of the whole, where we are all together through the generations and all at once.

In the years that followed the creation of the second *Of the Land* series, my dad made prints for friends and contemporaries. He worked with Sam Gilliam and Gene Davis as well as for former teachers from Howard, David Driskell, Lois Mailou Jones, and James Wells. He also went on to make prints and build a wonderful friendship with the hero of his youth, Jacob Lawrence. In another remarkable opportunity, in 1997 he was commissioned by alumni of Howard to make a color silkscreen print of the original woodcut image that renowned artist Aaron Douglas, born 1899, created as the

bookplate for Alain LeRoy Locke. This bookplate was the frontispiece of Locke's 1925 book of philosophy, *The New Negro*, the inaugurating text of the Harlem Renaissance. In recreating this bookplate, my dad completed a circle begun in his student days, where the seeds of art and philosophy at Howard were planted. He had been watered by art and love and life and arrived back at the university, now with roots strong enough to support him as a collaborator with history.

These works in this book point to the expanse of life. They invite all people to share my dad's special view on nature in harmony and to see his visions of the world—how human life is defined by nature and the natural world but open to an experience that in moments can lead beyond it to something spiritual. *Of the Land* shows the full promise and energy of being in the summer of life and feeling its warmth completely and totally. I see the roots of these works in this collection stretching through the trees' trunks and out to the skies that my father would later turn his eyes toward—these later abstract monoprints that fill the whole paper with pure abstract vision, pure sky. In these later, more abstract prints, begun when he was in his seventies, he reclaimed his ambitions as a young student and painter by painting directly on the screen. These skies were like warm breaths of life—pure inspiration that I would often keep in mind as I went out into the world to find my path and pursue my art. Like my father's circle, my path has led me here, to this city that I love, Washington, DC, sharing these wonderful pieces of art with you in this beautiful collection.

# OF THE LAND
## LOU STOVALL

## PRELUDE

. . . at a time in my life —
when Living and Loving
is one act of kindness.

February 1973

# PART I
## 1974

DRAWINGS

## PRELUDE

What kindness is said
of loving all living,
mine, I say, comes
from the land, and I
am enriched by that.

January 1974

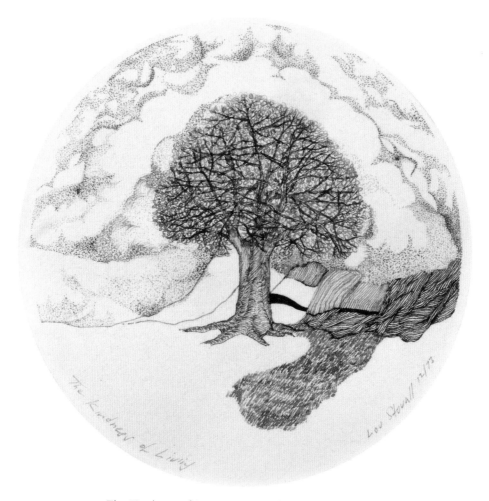

*The Kindness of Living*, pen and ink drawing, 1973.

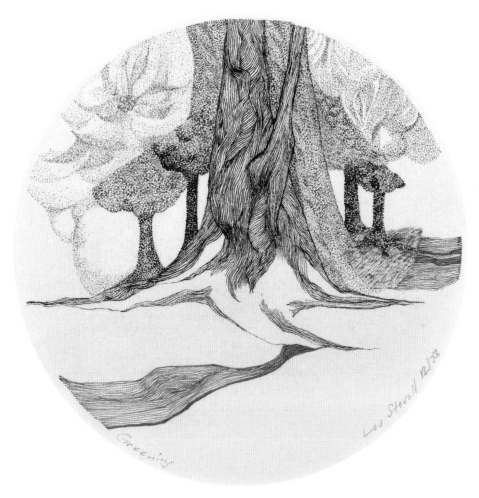

*Greening*, pen and ink drawing, 1973.

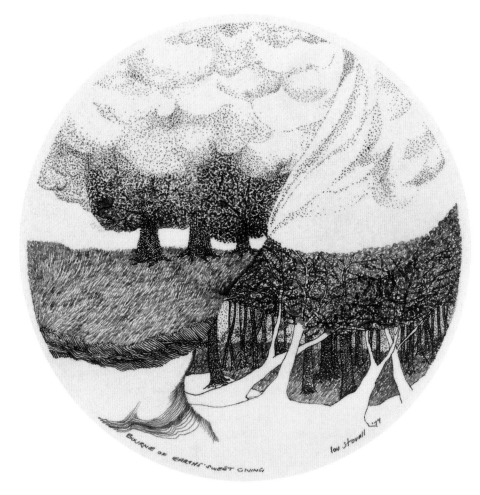

*Bourne of Earth's Sweet Giving*, pen and ink drawing, 1974.

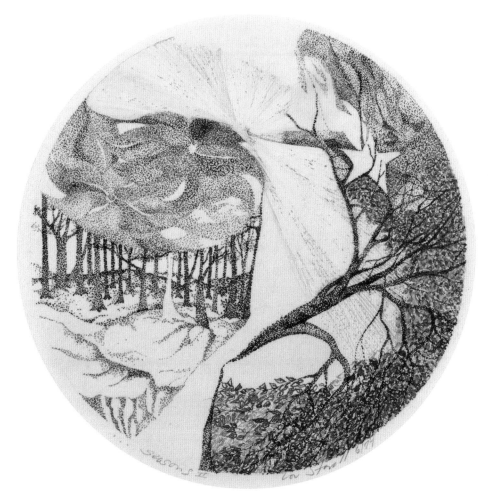

*Seasons II*, pen and ink drawing, 1974.

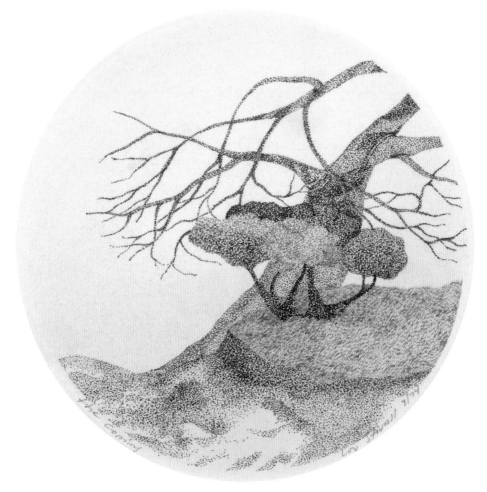

*The Coming*, pen and ink drawing, 1974.

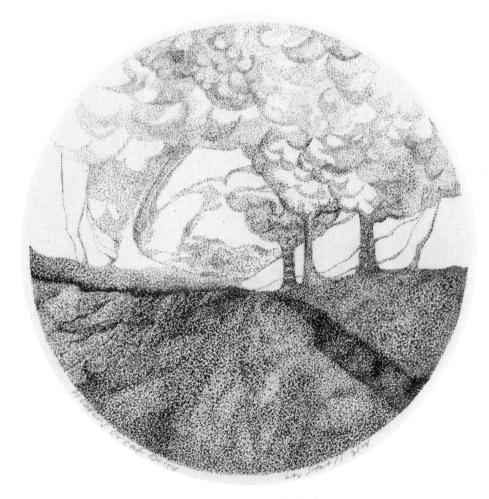

*Heaven's Great Being*, pen and ink drawing, 1974.

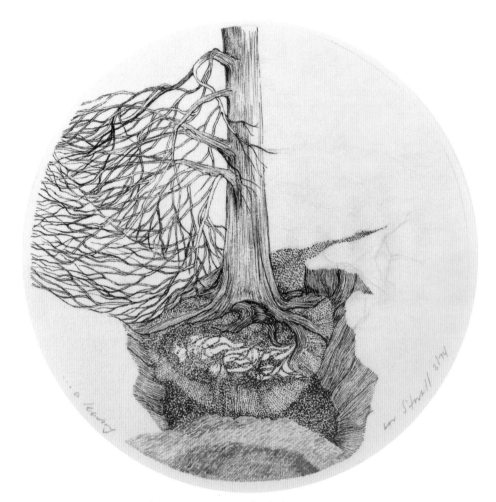

*A Leaving*, pen and ink drawing, 1974.

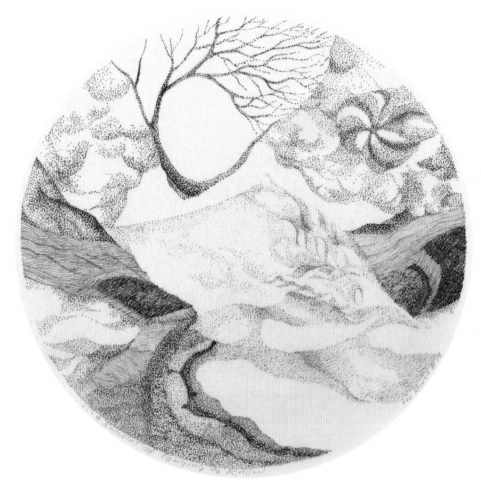

*A Knowing of Longing to Know*, pen and ink drawing, 1974.

PRINTS

## OF THE LAND

the Kindness of Living
amidst Love's Greening Land
is bourne of Earth's Sweet Giving
of Morning and Evening and Seasons.

and Knowing of this Believing
seeing now the Coming Yield—
break from Heaven's Great Being
and Exanthema of Clouds.

as Spring Becomes a Leaving
and Summer's Spirit Holds Love's Stay
the Bounty thus is Falling
and Winters bear the Promise.

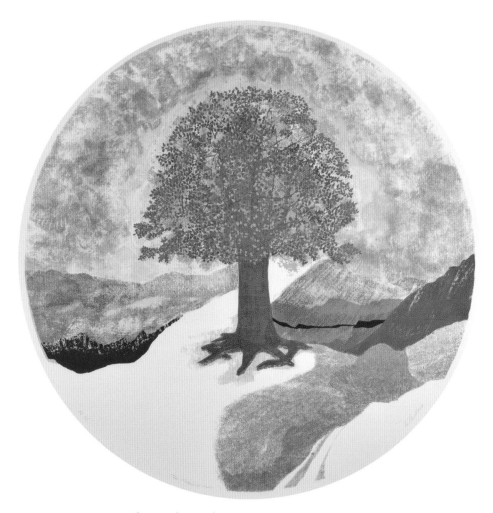

*The Kindness of Living*, silkscreen print, 1974.

## YELLOW GIVING

Golden halo, yellow coming
ringing rounds of rolling Spring.
Whispering of willowed wind,
dreaming dreams of everything.

Gently Down
Golden halo, yellow bearing
breathing hues of dewing dawn
and kindnesses that I intend.

Sweetly Now
Golden halo, yellow giving
singing songs of everything.

## GREENING

Amidst love's land
shines a particular ray
just a slimmer of sun
which led me this way.
Then warmed the cool
and stayed the day.

Fullsome this wood
grows wide and deep
a fortune enriched
for loving's retreat.
where seeing sees
my touching keep.

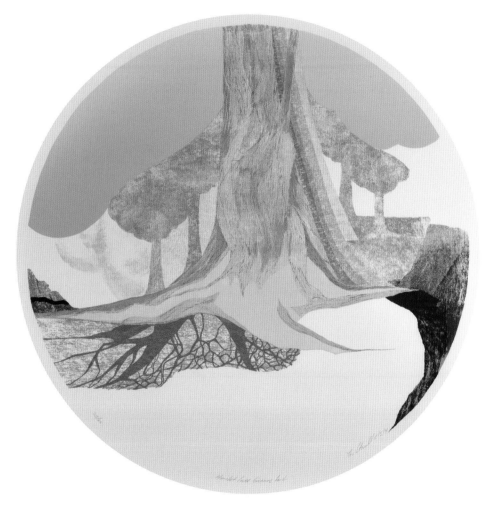

*amidst Love's Greening Land*, silkscreen print, 1974.

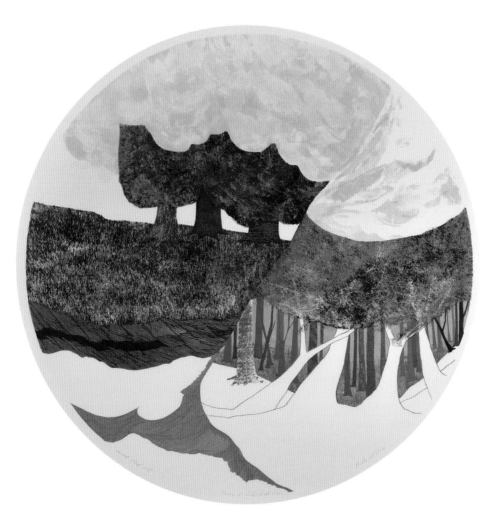

*Bourne of Earth's Sweet Giving*, silkscreen print, 1974.

## BOURNE

beyond search
sky clouds beginning
feather down
bringing up calm.

above desire
sky clouds rumble
deep with restless
noiseless passing.

below meaning
sky clouds erupt
over greenings
bourne of Earth's
Sweet giving.

## SEASONS

Could in meaning Springtime
a morning mist so mild—
there mouthing daily birthtime
of loving's lovely child.

Then enraptured early sunshine
is Summer's time beguiled
in calling sweeping chimes
to loving's lively pile.

Good Autumn's time is mimed
through Evening's mighty file
to give the best that's mine
for loving, living's while.

Deep Night must now enshrine
round Winter's distant mile—
wonder's glory now defined
in loving's lonely smile.

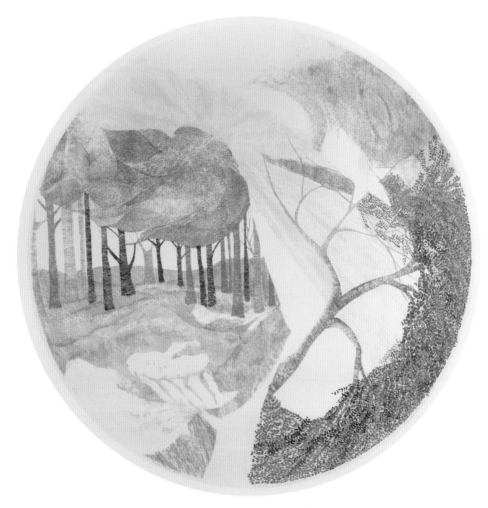

*of Morning and Evening and Seasons*, silkscreen print, 1974.

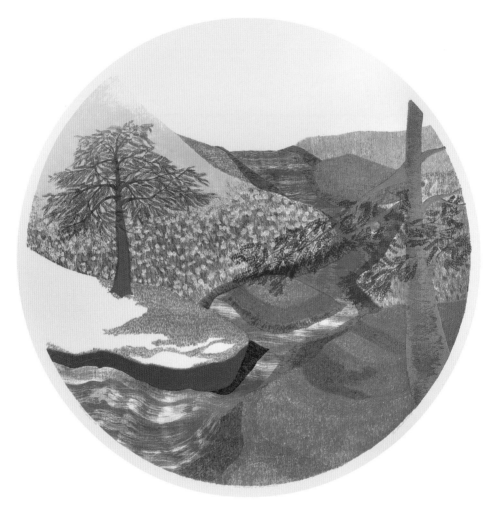

*and Knowing of this Believing,* silkscreen print, 1974.

## BELIEVING DAISIES

Sun sheared
bough broken
deep creasing stream
spills riches

    and grass grows.

A stealth of daisies
comes softly, like
living filled sweetness—
seeming all

    and land loves.

# THE COMING YIELD

I've known
some fields
I'll bravely say,
for I have sown
an oat today.

Call it seven
you'll hear me say
a direct route
is my highway.

Spirits high, help
keep me gay
for I will surely
earn my pay.

I'll sow an oat
each single day,
it helps to keep
me on my way.

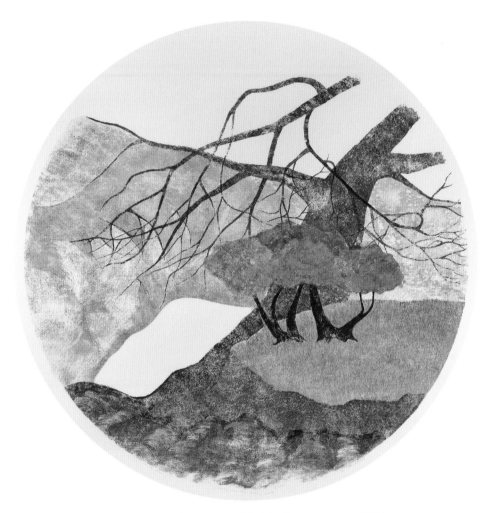

*seeing now the Coming Yield*, silkscreen print, 1974.

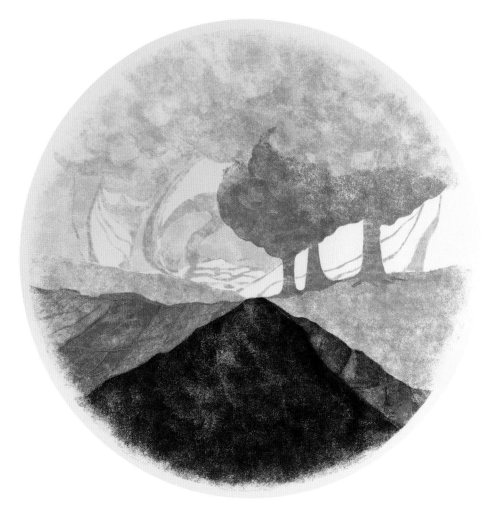

*break from Heaven's Great Being,* silkscreen print, 1974.

## HEAVEN'S GREAT BEING

shadow passing
before my cloud,
erodes
leaving voids.

There,
shallow limits
will sad eyes
to gloomy restraint.

There,
sightless,
raged against
the wind,
sinking beneath
its will . . .

I now believe.

# AN EXANTHEMA OF CLOUDS

Visions mirrored
in a sky
mirrors visions
of my eye;
of boughs that break
on gentle winds,
causing limbs to
weave and bend.
Clouds entrapped
of subtle hue,
mirrored still
in morning dew;
of grass that grows—
a grassy ride,
deepened still to my surprise—
and browing hills
go traveling
while purple clouds
are circling.

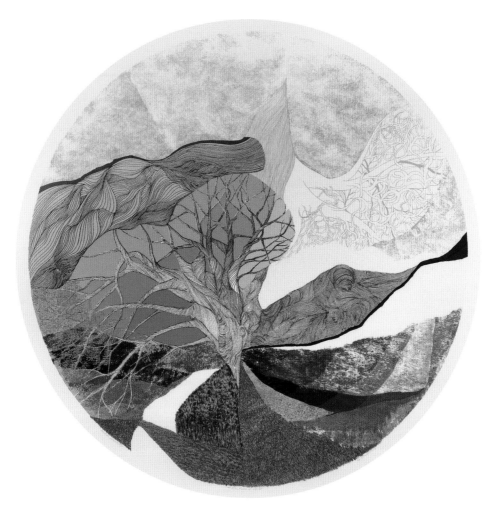

*an Exanthema of Clouds*, silkscreen print, 1974.

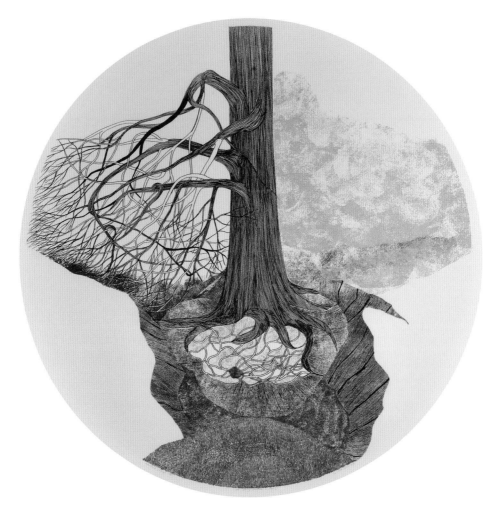

as *Spring Becomes a Leaving*, silkscreen print, 1974.

## LEAVING

A region knows
its heritage—
Its plenty
of what's sown.
In land that
nurtures vestiges
of seedlings
still ungrown.

## SUMMER

And Summer's spirit
holds love's stay,
slight gentle breeze
in sweetest sway.

Such ambiance
just graced my day,
and spilled a still
along the way.

Soft petal downed
cooled rushes may—
that raptured hue
enraptured stay.

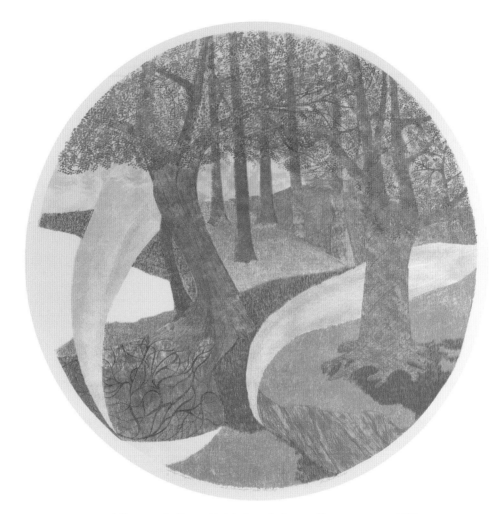

*and Summer's Spirit Holds Love's Stay*, silkscreen print, 1974.

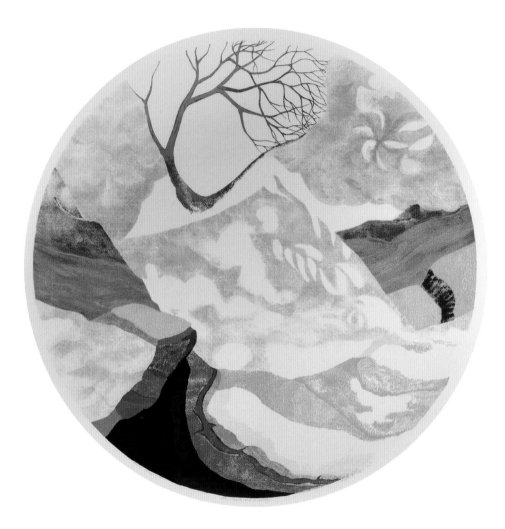

*the Bounty thus is Falling,* silkscreen print, 1974.

## FALLING

Pleasant hill in land so filled,
filled by nature's care.
Grassy slopes in valleys green
scene by no one's fare.
Calling here and calling there
winsome wind so fair.
Falling leaves were everywhere
taken up by air.
Flown high and wide upon a wing
skies are cleared of everything.
Knowing of some valley's deep
pleasant hill above me sleep.

## PROMISE

Winter's light
of Heaven's might
bears its promise true,
of endless lands
and chilly sands
and skies of lighter blue.
Big old tree
that dreaming me
bared its branches too,
from Summer's end
and Autumn's trend
remembrances of you.
Free birth here
no plan to fear
bare trees have their due
of leaves in Spring
Sweet offering
and love I have for you.

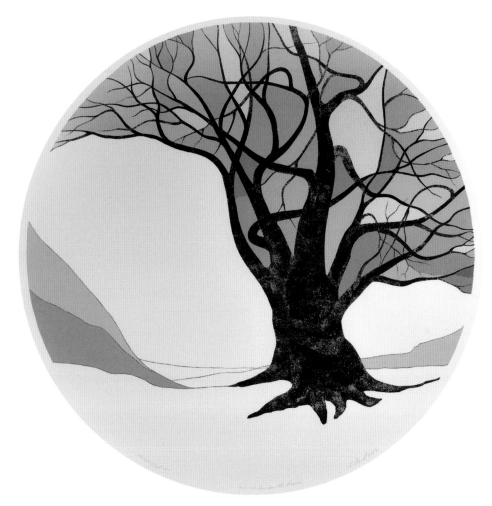

*and Winter's bear the Promise*, silkscreen print, 1974.

# PART II
1977

DRAWINGS

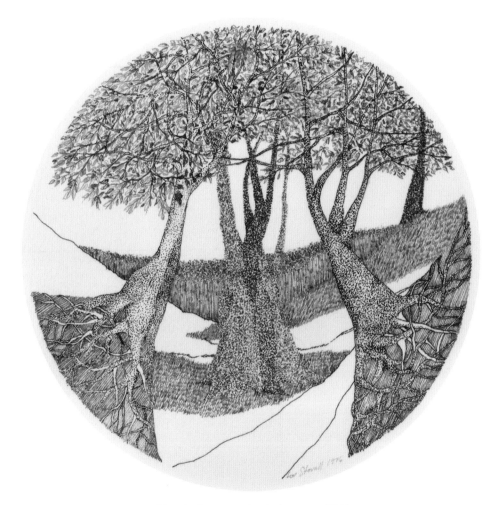

*Untitled*, pen and ink drawing, 1976.

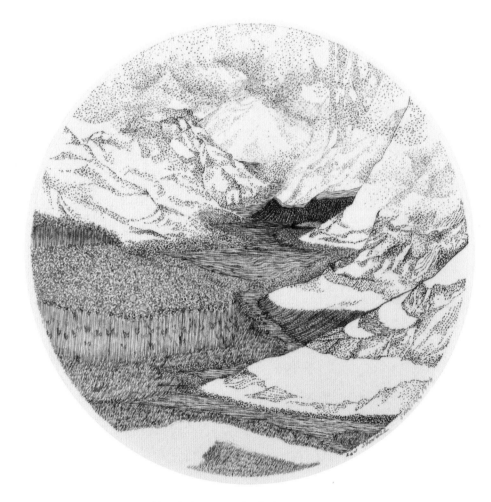

*Untitled*, pen and ink drawing, 1976.

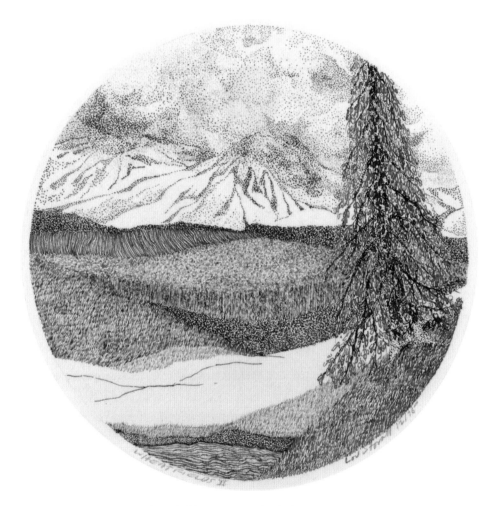

*Wheatfields II*, pen and ink drawing, 1976.

PRINTS

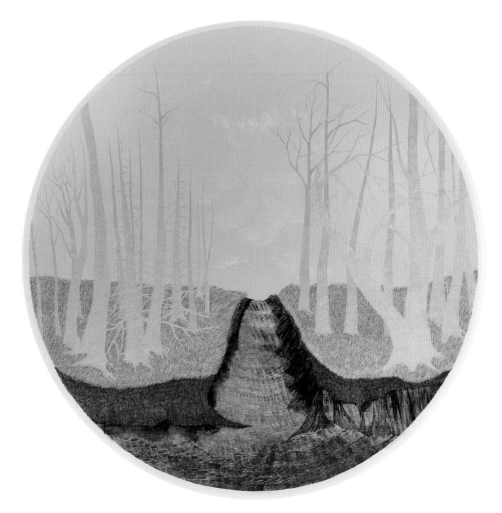

*of forest deep*, silkscreen print, 1977.

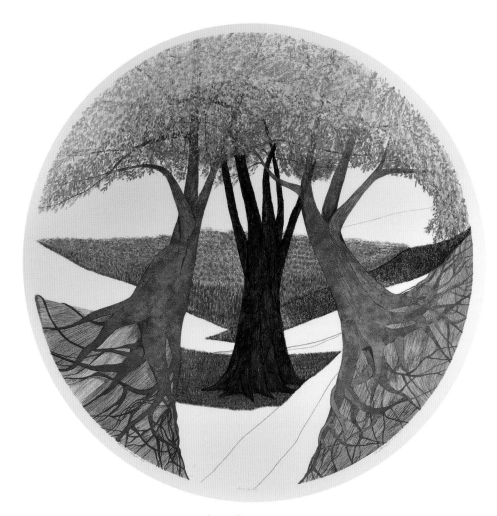

*time to be*, silkscreen print, 1977.

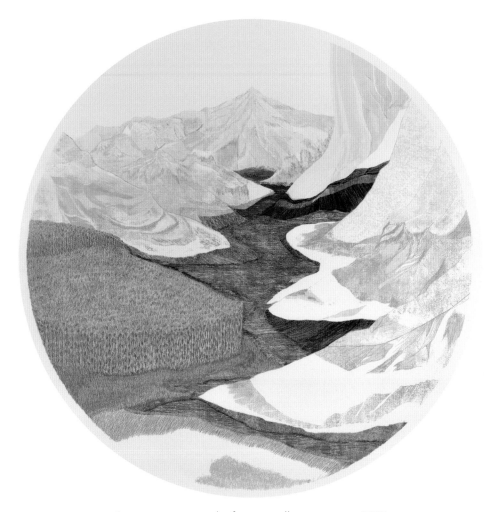

*Love, ever so gently, fantasy, silkscreen print, 1977.*

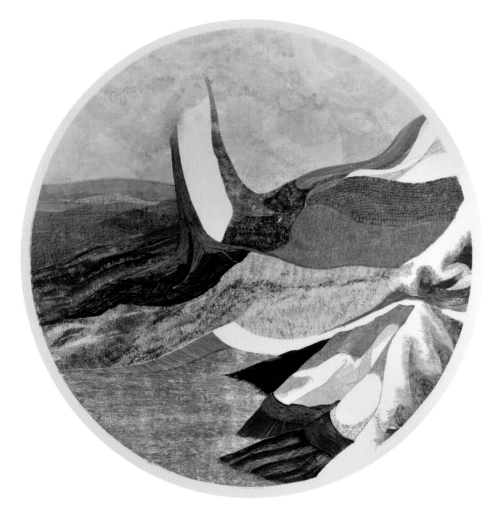

*Comes Wanting*, silkscreen print, 1977.

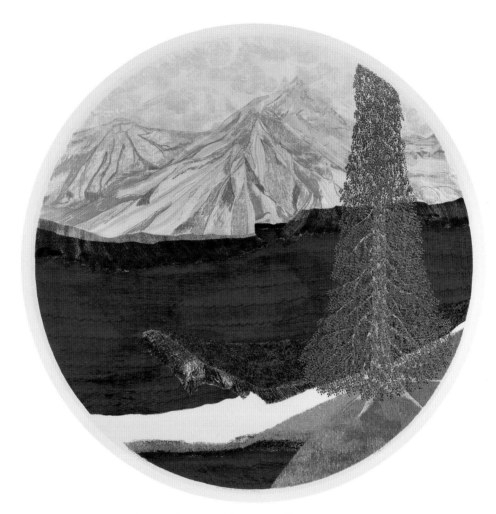

*In beauty born and bearing*, silkscreen print, 1977.

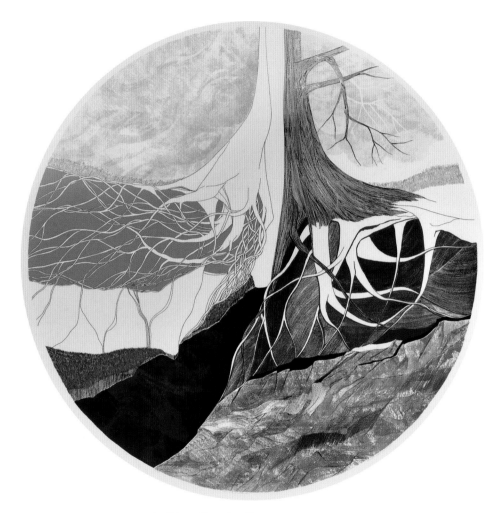

*In Silent Reach*, silkscreen print, 1977.

# ORIGINS

# ON THE GREENING
# OF THE ARTIST

I always thought that knowing morning
was enough to know.
That was when making art was all there was.

I want to share my greening with you;
my art, my music, and my thoughts.
I want to share with you how I finally gained a sense
of myself that I could live with.
Being an artist is an awesome task,
most of us do not know how scary it is until we are too old to do
anything else.

I grooved on the thought that
"Art is long. . . . Life is short."
I thought to make a quick impression,
to leave something with my name on it.
But then discovery happened . . .
At first I only heard the words,

"...My heart in hiding, stirred for a bird—
the achieve of, the mastery of the thing!"
That was Gerard Manley Hopkins.
I knew then that someone had shared before.

Tonight I said it was the magic room,
suspended between first and second.
Magic at first because it was my own.
But more because it was in a strange place.
I could never abide strange ... so I worked at it,
not intentionally just to change it—
I worked on it, because it was there,
to make it a place where I would want to be.

That is how and why artists make old warehouses,
garages, basements, and lofts into special places.
It is a magnificent power that we have
to find beauty and charm in things.
To make special of a room that could only be reached
from the back of the kitchen
or from the third-floor back stairs.
That was my gift ...
the ability to make something possible
is perhaps the greatest gift of all.

That room is firm in my beginning.
It became my philosophical statement—
my first aesthetic position
and I likened my situation to the existence
of other rooms, like The L-Shaped Room,
a film that was passionately nonconforming,
and *The Blue Room, A Room of one Zone*
and much, much later, *A Room with a View.*
That room was a place for art and thought . . .
a place where a young artist's life could begin.

I gorged myself on that beginning,
packing the references into every available
crevice of my landscape.
I took the words and the hopes and desires—
the poetry and the prose—the dreams—the opera,
Jazz and Mozart (a world unto himself)
and John Lewis, Thelonious and Beethoven.
I shouldered the philosophies of the ages,
learned to say existentialism,
and played chess for hours
and days without sleeping.

You could not have convinced me then
that *Henry the Fifth* was not written for me.
I longed to hear the call—
"We few, we happy few, we band of brothers."
I took my Grandmother's warning,
there would be no devil's workshop for me—
my mind was full, my hands were busy.
My father said, "Well, you had better be a good one."
I had enough starting power to last a lifetime.

Everything was for me and I was for everything.
Some things I thought about, some things I did.
Judgment was a game, art was the name,
if anything delayed, confused, or interrupted,
the sacrifice was sleep, time to eat—
whatever could be spared was sacrificed for art.
Like blues music, I was transported.

The warm black walls were hung
with my paintings and drawings
and then draped with seine netting,
the ceiling was starred with album covers—
and only strategically covered with the fishing net.
It was not so much a stage set as it was a fantastic tent.
One deep purple wall from a tune that I knew.

A few stolen traffic signs leading up the stairs—
the diamond shaped detour at the top
and pointing cleverly, opposite the door.

Like the sea
the wonder of discovery
would come in rushes and whispers,
sometimes as if beside a brook.

At those times I thought of other rooms . . .
Five Spots, Birdlands, and Storyville—
Red Doors and Shadows
and Cellar Doors, Bohemian Caverns
and later salons and theaters.
Some I knew from fabulous visits to New York,
Washington, and Boston.
Others I knew from the music that originated there.

I came to love California
with Concerts by the Sea
and I covered my floor
with a beach-colored grass mat . . .
one black butterfly chair, one easel, one paint stand
and a rolled up or out foam rubber mattress—
either bed or couch.

In one corner the book case, mounted on the wall,
heavy with the volumes of my days,
connected by the desk where long letters
of "Being and Nothingness" were written
under the light of the requisite pole lamp.

Under the corner of the desk hung the speaker—
hand made from the Lafayette kit—
my first really essential furniture—
a twenty-inch column of woofer and tweeter,
not enough money for a mid-range or crossover
and certainly pales by comparison now,
but then, it was a powerhouse of bass and treble,
it was almost like being there—
in the club where the sounds were made.

Malcolm, my friend, was usually on the floor,
his head somehow wedged under the speaker—
I thought he would surely make himself stupid,
like everyone said,
"with Percy Heath's bass pounding on his earlobe.
He wanted to get as close as possible
to the source of the music" . . . We all did—
I did not have the words then
to tell him that it happens in the heart.
That to be one with the sound was to be inside.

But that was a year or so before Zen
and meditation—before three-button suits
with skinny little ties, before I knew my sign
or that someday someone would care to ask.
But not before I knew that five— my number,
was the number for art —
and that twelve belongs to the universe
and that "body, mind, and spirit" was good.

Jane was in the corner, beside the easel,
just behind the paint stand,
her patience was the only thing—
more beautiful than her profile.

The elusive light that played across her cheek,
disappearing softly under her chin—
the line that I painted always seemed so strong.
I must have learned to work with a steady hand
while I practiced uncountable strokes—
forever chasing the loveliness of a disappearing line,
a lifetime of exquisite subtle colors, dark into light,
a drifting cloud, the spray of sea . . .
sound into line—perfect passage.

Andrew, my cousin,
always seemed too large for the butterfly chair,
his presence overflowed that canvas sling
just as the memory of his affirmation of my life
and style and my choices overwhelm me now,
Only my mother had more faith—
to be valued is like receiving a rite of passage,
to make someone believe is the second great gift.

But we were young,
so young to know that black bread
and red wine was only a temporary repast.
I got past that, and found that Thelonious Monk
was a main course,
different than the Modern Jazz Quartet;
but still ultimate—
compelling and unforgettable is better . . .
only now I can see that his "Little Red Wagon"
was a state of mind—
I could not think of that until now—
in reflection I see myself promising my son tomorrow
and later pulling him in our own little red wagon
"until the wheels might fall off"
as Doug and Esther said and later, much later,
I thought that he, my son, and you and later yours

should know the right and the legacy
of the drawings and the sounds of music and art.

And so I have cleaned the old records to put away,
this time safe from dust.
I have saved Il Travotore and Monk and Garner
and Dylan Thomas reading and Gigli
and de Los Angeles, Tebaldi and Aretha—
and I have saved Beethoven's Fifth
Brahm's Double and Mozart's Twenty-First.

I have saved the thoughts of Ben and Claude
and Billy and myself growing up
and all of the Sams in my world
and Donalds and Phils and Lloyds,— and the
Andrews, Jacobs, and Davids and Walter—
who are continuing reincarnations
of longness and the tallness of destiny.

And I have saved the honor,
the memories and the hopes and thoughts
of Jane and Di and Calea
and Elizabeth reading Margaret Walker to me
and all of my friends, and my mother and yours
and their mothers finding beauty and charm in everyone.

Some more to know and to feel—
that the lines and the sounds
of cool and hot and passion and soft,
as in a morning's sunrise—
two degrees east—three degrees west.

This poem was delivered by Lou Stovall as the commencement
address at the Corcoran School of Art in 1992.

LOU STOVALL

# MY STORY

My poem "On the Greening of the Artist" represents a series of vignettes from my life in the fifties, essentially my teenage years. That span, from age thirteen to twenty-three, is complex and filled with activities that surprise me even today. At thirteen I had already begun to read the great philosophers. By this early age, already I imagined myself to be a child of destiny . . . that all children are born into a world of souls that were left by each person who had departed life. These souls made up the universe, of which bits and parts of each would go into the soul of each child born until the complete person was made. I have always believed that humankind basically tends toward the good, too. Consequently, I believe, I was destined to be what I am.

I think it is important that you know that at that particular time in my life, living and being young gave me poetic license to separate my life into two all-important entities: the mind and the body. I hung out with my friends on State Street. State Street in mid-fifties Springfield, Massachusetts, was one of the few places young people could be in groups and not risk being sent home by the police. That area held fascination for us because many of the high schools, museums, and libraries were there. We made up games, walked, talked, and imagined ourselves in all sorts of different configurations. We fashioned ourselves into the Progressive Gentlemen, a very informal club.

There was not a prevalence of artists in my neighborhood. There was not a real artistic person in my family. I remember knowing what I wanted to be and what I wanted to do at an early age, and, of course, it was art. I was about three or four years old. I never thought about anything except making art and being an artist. Much later, the realization of how to support myself as an artist would come and I would begin working toward that. I believe my first indication that I had any innate facility with the arts came when family members and neighbors encouraged me and actually paid me to make cabinets and bookcases for them, and, most importantly, when they put my drawings on their walls and asked for more. I had learned to work with wood from an early age. I had an uncle who worked a night shift job who, along with my father, taught me to use tools.

Kids are often asked, "What do you want to be when you grow up?" All kids answer according to their experience. They want to be doctors, lawyers, firemen. There was an old poem about it. I think that we kind of decide what we want to be early on. No one ever really pushes that on us or tells us, "You have always said what you wanted to do, now let's see that you do it." But for those children like me, who always had a sense of what they wanted to be, they live for a long time in the act of pursuit before they even know what they are doing. One of the things that I remember my grandmother saying is, "an empty mind is the devil's workshop." From that old adage you understand that your hands had better be kept busy and your mind busy as well. My father always felt that someone who was or appeared to be as good with words as I was—and I was able to talk my way out of all kinds of situations—should become a minister or a lawyer. But those were symbols that were held up to him. It had to do with jobs that one could aspire to in order to attain a better life. He never thought about art because he did not know any artists and, most likely, never thought of any artist who had done well.

There was a man in my neighborhood in Springfield who made pictures and so on. He was the first person who taught me how to draw, so my first drawing lessons came from him. I especially remember drawing horses with him. But no one ever thought that it was possible that I would continue to be fascinated with drawing after childhood. He moved away and we lost touch when I was about ten years old. My mother became my solid support. It was typical for Black families to be matriarchal. My mother decided what everyone was going to do, and my father went along with it. His job was to work and provide for the family. He did that and my mother always saw to it that there were paper and colors for me with which to work.

I was born in Athens, Georgia, in 1937. By 1941, when I was four years old, there was a great migration North to find work and living conditions that were not totally segregated. My father had decided he didn't want his children to grow up in the segregated South so he moved our family to Springfield, Massachusetts, where he found work at Westinghouse Electric Corporation. It took me years to figure out that this was his great gift to us. Before that time I had always thought that my mother had given me the greatest gift—believing in me and sharing in my excitement about discovery and so on. But had it not been for my father's resolve that the possibility of opportunity, which was what he wanted for his family, would be found outside of the South, then I might never have known the feeling of what it is to pursue a goal with a full heart. With the move, we were in a place where we could live a little better life.

There were some very important people who were the most responsible for the way that I began to think. When I began to think in terms of what it would be like to be an artist—and could communicate those ideas—of course I thought of the man who first taught me how to draw when I was very young. The second was my high school art teacher, Helen Norgaard, the angel of teachers, who guided my abilities to

higher planes. She introduced me to a world of discovery, opera, silkscreen, and literature, which all became so important to me. She nurtured my capacity to learn, observe, and accurately record my perceptions. There was a point when I was ill—I'm not sure what illness I had—and I was out of school for a rather long time, in terms of weeks and months. I remember that she came to visit me and brought books and school assignments, so I was able to keep up without falling behind. She is someone who I will remember forever.

I remember when I was fifteen and a half, I discovered a man who was silkscreen printing in the basement of the grocery store where I was working part-time. I was so excited about silkscreen. As I recall, I was downstairs having been sent for bags of something and there was this chemical odor coming from a corner. I saw there a man who I later learned was printing off grocery signs. He said, "Don't just stand there. Take this and put it over there." Before I knew it, he had me running around the basement like crazy. The stock room was in the basement of the store so the canned goods and boxed goods were stacked in aisles and rows in the basement. The system he came up with was to spread the paper—the wet signs—out on the boxes until they were dry. As he was printing these store signs, I was observing everything. I completely lost sight of what I was supposed to be there to get, and, an hour or so later, the store workers upstairs came looking for me. When the store manager realized that I must be downstairs, he came and found me running around the basement, putting the signs around for the old sign printer, who said, "From now on, whenever I'm printing, this kid's going to help me." I'll never forget that.

In high school I was so excited about silkscreen printing that Helen Norgaard, in the very next session, brought in a silkscreen kit, a small one, and gave it to me. She said, "You know you can use silkscreen for more than just making signs." She taught

me other ways of making prints. And so, at the age of fifteen and a half years old, my fascination with silkscreen printing began.

Under Ms. Norgaard's tutelage, I became the school poster maker. Poster making became the substance of my community involvement as a young adult. I had the assurance, the will, and definitely the ego to be an artist. I would not be deterred. My father, at the urging of my mother, finally resigned himself to my destiny. His parting words to me, "Well, you had better be a good one," still seem engraved on a transom under which my every thought must pass. In the late 1950s, my hope and opportunity for a broader artistic community seemed sure to come. I have come to think of this period as a threshold in my life, and the words from "How I Got Over," adopted from church services at the time, became a frequent refrain in my mind.

I won a scholarship to study at the Rhode Island School of Design, where I went after high school in 1955. I studied there for the year, which was a year of work and learning but also challenge, as in those days of segregation I couldn't find an apartment willing to rent me a room in Providence near the college. My commute was lengthy, and just as I was able to settle, my father became very ill and soon passed away. I finished up the second semester and returned to Springfield to support the family, taking a job at a supermarket. The urgencies of helping the family made me put my dreams of college on hold. I worked and helped for six years until I was able to be a student again, but this time it was at Howard, which was often on my mind.

In 1962, I was twenty-five years of age and enrolled in the Howard University College of Art as an undergraduate student. My primary interest at that time was painting. I was so taken with renowned professor James A. Porter's knowledge and his eloquent style of lecturing that I sat-in with his classes whenever I had free time.

Subsequently, as I learned under his tutelage, he became all that I could imagine one man could be in the world of art appreciation. While I continued to pursue painting and printmaking, I also concentrated on modern art history. As his student, I gained access to his mission to teach and to learn intellectual curiosity and to encourage provocative thought about the drive, meaning, and substance of modern art. We were in a time of anxious search to understand abstract drawing, painting, and sculpture. Few of us had traveled much beyond our neighborhood. World art was new to us, and many of us were all about landscape and only had it and still life for subject matter. Dr. Porter opened our eyes. He was an expert in the field of African American, ancient, and African art, and he was called frequently to prepare statements for authors and news people who were commenting on exhibitions and acquisitions.

And still he made time for his students; "Come with me," he would say, "and bring a few others with you." Those sessions in his car, driving throughout Washington, DC, a city he termed as one "of immense beauty and resource," reassured my commitment to make Washington my home—a sense that I had formed from my first two days. He said, "Practically every style of architecture in the world is somehow represented here. We have only to learn how to see what wonders we have."

He taught the difference between looking and seeing and left it to us, his students, the viewers to make our choices. Back in class we had discussions of heritage and legacy, style and format, the value of the uses of history and the embodiment of the whole person as intellectual formed opinions of connoisseurship, and he again left it to us his students, to follow. Whole phrases of beautiful prose coursed through the room as winged muses with hopes of sweet reward for the well-turned remark.

Porter loved literature, music, and fine language. He rewarded us with a continuum of thoughts that fueled our revelation of discovery. This I do wish for you, an understanding of the nature of a man and a woman who carried with precious pride the stories of those who came before to stoke the fires of learning that would last well into our future so that someday all will cherish the contributions of our Black American forebearers. As prevalent as some jazz terms were, the words "jive" and "cool" were somehow never uttered in his class.

The other greatly important and influential teacher I had was painter and graphic artist Professor James Lesesne Wells at Howard. He encouraged my thorough nature. Mr. Wells, as he was known by most, supported my inclination to take the time to make good prints and to keep my borders clean. When a project required more time, he would ask what time we would like to start in the morning. When additional materials were needed, he supplied them, and I think it was at his personal expense. Where silkscreen was concerned, I had become fixated on fastidiousness. For example, I learned with experience to sense the ink on my hands before I handled the paper. I was amazed by the amount of errant spills and marks that could be avoided by planning where to place the various tools during the printing intervals. Every seasoned printmaker is a teacher, and every artist with an ambition to make multiples should become a willing student.

Mr. Wells recognized in my statement of purpose that I was a kindred spirit, in that we both thought of printmaking as our life's pursuit, though he engaged himself with relief printmaking and I pursued silkscreen printmaking. We both embraced craft as our God-given direction. Wells was a master craftsman, continually

pushing the limit of existing traditions as he sought to extend the possibilities of the medium to match the challenging demands of his artistic vision. That also became my mantra.

In my talks with him, I shared my thoughts to accomplish silkscreen printmaking as the best medium with which to make art because it had the possibility of clarity, brightness, and strength of modern art. It was all about making images that were bright new creations, geometric as well as organic and painterly. Beautiful pieces that could be affordable at a time when it seemed the ever-increasing prices of art would be out of reach for young collectors. It was necessary to establish an accessible market.

After graduating from Howard, I continued to build my community in Washington, DC, and found a small space to use as a studio where I could keep discovering. Early in the 1960s, my classmates and I gathered the strength of our mutual friendships to better the world in which our children would live. We were changing the world. During that time, I made a lot of posters for various groups and in support of important ideas.

There is no doubt that many of the posters I made in the 1960s and 1970s caught the eye of a huge variety of people and affected them. A good number of those posters still adorn the walls of homes, offices, schools, clubs, and public institutions. It is impossible not to reminisce about the posters from time to time. First, no money was ever paid to me to create the protest posters. What few dollars were volunteered from the protestors was used to buy poster board and paper. Somehow paint always seemed to be available. I found that few graphic images were strong enough to replace or balance the urgency and the energy of bold letters. I had played with letter-

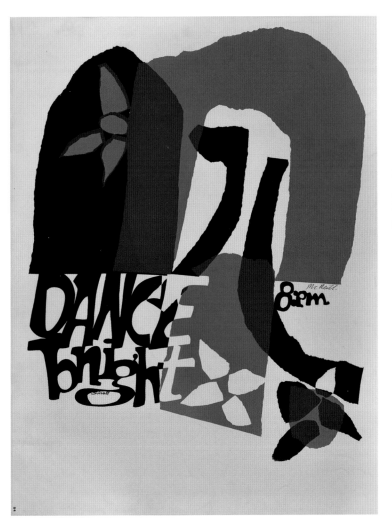

*Dance Tonight*
poster for
Summer in the
Parks, 1968.

ing as a means to express power, and I thought only of the universal message that each brother and sister wanted to carry hope and strength.

During that time, I remember being called to my hometown of Springfield by friends who were protesting for human rights. They picked me up at the airport and drove me to the court house steps where I found poster board, paint, and brushes behind one of the massive columns. I immediately set to work to supply the posters on demand. It was after dark when I finished, and, after a quick drive to my mother for a hug goodbye, I was returned to the airport to catch a flight back to Washington, DC, where I would make it to my early morning class the following day. There was no looking back in those days. I later wrote in a letter to the daughter of a friend who had passed away:

> Morning came all too soon in those days of commitment. There seemed never to be enough hours for school, the movement, and work. We looked to music, art history, and literature to form our philosophies. We knew that the exchange of culture and shared intellectual pursuits could ease the flow of understanding between people and different worlds. We would make our world accessible to everyone.

From my days as a young student in the fifties, I had carried my passion for art and music with me to DC. I was welcomed by the Bohemian Caverns, Washington's most well-known jazz night club and one of a half dozen nationally famous jazz clubs. I was welcomed by the music and by the opportunity to make posters for the performances and by my need to do so. For me, the dual purpose of my art is very much like improvisation in music: Art and music do in fact inform and entertain at the same time. Improvisation provides shades of emotion. These emotions were a

glue that tied me to making drawings and posters for musical events. Tony Taylor, the manager of the Bohemian Caverns, gave new meaning to the title "jazz impresario." In the jazz tradition, he fathered the greats, the near greats, and the babies who came to worship. For me he was a father, brother, son, friend, chauffeur, protector, and tour guide, but not a client. Tony thought the arts should be free gifts to all who came to witness. His unique manner of handling payments was to say, "Hey brother, let's talk about that." This was a method that actually worked with me and many of the musicians who came to the club to perform.

Tony was an important presence at the studio. When I was making posters, Tony would come to "help," which amounted to his telling wild and hilarious stories of the doings of jazz musicians, artists, and patrons, all the while directing whatever action was going around in my studio. On one occasion during the printing of a large run of posters, his booming basso voice delivered, "Hey man, now you know you can make a hook for the girl to reach those high drying racks?" The practice in the studio had been to grab the print, jump up on a little box, throw the print on the rack, and jump down in time for the next print. Hopefully, my assistant would not miss the box, because the prints were mostly on twenty-three inch by thirty-five inch sheets of paper, too large to see around. Tony was fond of my assistant, Di Bagley, a young woman who had come to Washington to study art and who I later married. He seemed to be always around, and he always had a very large and audible presence wherever he was (including at our wedding). He had a huge crown of hair that was complimented by the most interesting handle-bar mustache that somehow seemed a total match for his unique voice. He saw to it that Di was treated wonderfully, as if she were his daughter. Tony could intimidate even the boldest of spirits, yet Di reigned in a special place as the one who held his attention. Later, when she was ready to design and

print her own posters, Tony was the first to help her, reminding me that he, too, was once a student of art.

At that time, Di was my principal assistant. I have thought of silkscreen printing as a kind of dance or sport and printing as fast as was humanly possible was the game. She set the standard for racking prints, mixing colors, and maintaining a sense of order among the interns and visiting students, all the while learning the medium, cutting stencils, making her art, and keeping an eye out for Tony, whose health was challenged by diabetes. It was never about the money but about getting on to the next event. We printed the posters, delivered them to the Bohemian Caverns, and then stayed for the music. Much later in the night, when the jazz was over and Tony had given his, "Hey brother" performance about payment, he would drive us to our nightly haunt, a restaurant in Georgetown where the pancakes, eggs, and bacon were put on the grill as we came through the door. We had the ritual down to a script: We exchanged our appreciation of the performance, told a few jokes, and commented on certain patrons of the show whose ever delightful and interesting fashion display created a spectacle designed to impress the jazz gents and ladies. Almost immediately after eating we would fall asleep at the table. Di would wake us up before our snoring disturbed the other late-night diners and drive everyone to their respective homes. In those days there seemed to be no difference between night and day.

At the time, I also was working for a commercial sign shop, just across the DC line in Silver Spring, Maryland. Harvey Botkin, the owner, had given me his permission to make posters for the civil rights movement in the sign shop, with the provision that I do his shop work first and that any money earned would go to him to pay for materials. Most nights I worked for several hours after the shop had closed to make posters or to experiment with silkscreen printmaking. In one instance, Botkin

was pleased by an actual paying commission—a fundraising print for the Mississippi Freedom Democratic Party. It was quite a deal, as usually the protest movements with money could be counted on one hand. In spring, April 1968, the movement at the time was a protest led by the Student Nonviolent Coordinating Committee, better known as SNCC, and the subject was "Heroes." SNCC leader Stokely Carmichael was a friend from Howard University and was desperately trying to aim news attention toward the students who were involved in voter registration and away from what were clearly becoming daily incendiary reports of impending violence. The day before, I was standing near Stokely as he was railing against some of the press who had editorialized his cautionary radio announcement. He had said, "If you are coming out into the streets with guns, you should prepare to die," but they changed it to read, "Come out with your guns." The following evening when the telephone rang, Di answered and held up the receiver. Tony's booming voice said it was getting too hot downtown and that he was coming to pick us up at Botkin's sign shop. I said I had to finish the posters for Stokely before I could stop working, and that I wanted to drop off the posters on our way. The Bohemian Caverns was located on the corner of Eleventh and U Street NW, just three blocks east of the Fourteenth and U Street SNCC office. Later, while driving back to DC, Tony supplied the details of the fallout from the shooting of Dr. Martin Luther King Jr. Seemingly within moments of the announcement that Dr. King was dead, bricks and bottles, followed by makeshift Molotov cocktails, flew through the windows of shops along Fourteenth Street NW. In retrospect, I do not believe the Heroes poster was ever used.

During the next two or three weeks, Tony drove us on tours around the city to check out the damage from the looters and the National Guard. I cannot think of that time as a time of riot. We were under curfew, but I do not recall any reports of citi-

zens being physically hurt, although neighborhood businesses were hugely affected. When Tony was stopped by policemen or soldiers, they immediately recognized his car and inimitable style, and gave us safe passage with a warning to be careful. The whole city appeared to be about to go up in flames. I recall on that first night, four or five blocks south of U Street NW, a line of policemen stretched across Fourteenth Street NW, waiting for orders to stop the looting. The orders never came because, in his wisdom, Mayor Walter E. Washington realized the frustration and impossible situation of his citizens in the blighted areas of Washington, DC. We saw whole families carrying various household items out of stores; two older women struggling to hoist a queen-sized mattress onto their shoulders, teenagers loaded down with boxes and bags of groceries, and a steady stream of itinerate men and women carrying cases of beer and liquor. Mayor Washington stood up to J. Edgar Hoover, who had called him in to order the looters shot. Mayor Washington believed in the words of Dr. King, who said "always avoid violence."

The mayor insisted that lives could be saved, property repaired, and goods replaced. What he could not have foreseen was the opportunistic thievery. Downtown, some thirty blocks south of U Street NW, we saw the hilarious effort of a man struggling to put a very large television set into a teeny, little sports car—which, strangely enough, had Virginia license plates. Stranger still was the call from friends of friends in suburban Maryland to come and view a cache of fur coats with the ostensible purpose of a purchase for my "girlfriend." I said "thanks but as far as I know, my earth-conscious girlfriend would never be seen wearing a fur coat. However, she is incurably curious and would probably love to see what you have."

As the uprising quieted down, people across the city were engaged in efforts to

rebuild the community. We were also asked to make posters to protest the war. Although we were driven by serious movements and causes, making posters for the Bohemian Caverns and for the antiwar protests was also entertaining. People went to great lengths to steal the posters off the trees and walls. We countered by nailing up several posters together. The poster collectors cooperated by continuing to steal one and leave the other to advertise the upcoming event.

My most notorious poster thief was a stylish connoisseur who had a love of my posters and a flair for party crashing. If he didn't crash a party, the party was not considered a success. People went out of their way to inform him of parties without actually inviting him. After all, the point was for him to crash. Once, our unnamed party crasher and poster thief threw a sumptuous party of his own at his Georgetown house, a rabbit's warren of rooms and staircases leading to surprising rooms and levels. In addition to his friends, he also invited all of the people whose parties he had crashed, and he invited us, whose art he had co-opted. Upon arrival, we saw the posters we had made hanging on his walls, the sheer number of which was beyond our imagination. From high school events, to protest and music performances, the posters were a product of my beginnings as a student in pursuit of beauty. The artist that I am today was born out of those beginnings. I thought to make the posters as good and beautiful as the energy required to put together the protests and other events. For me all of the action was in the cause of art. The more attractive the poster, the more attention was gained.

Making posters became my principal business. It was as if Helen Norgaard had given a direction that I never sought to put off. Posters definitely fueled my ambition to be a full-time artist. I was hired to make posters for an ever-increasing audience.

*Peace Corps* poster,
silkscreen print, 1970.

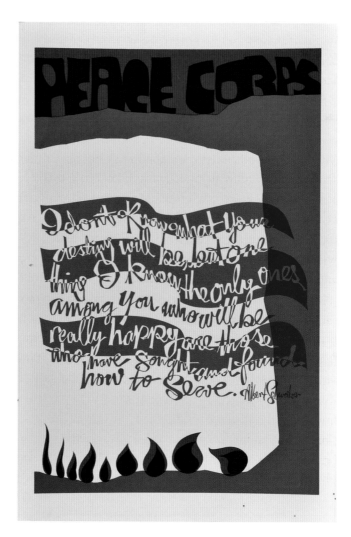

Much of my work came from government agencies. Along with the concert and event posters, I made posters for Job Corps; Peace Corps; Arena Stage, a local theater; and a few colleges.

In the early 1970s, I took a leap of faith and sought to perfect my technical use of the silkscreen medium. The wide range of styles, techniques, materials, and formats with which I worked then and now are a testament to my willingness to take on every serious printmaking challenge. I thought that to truly master the medium of silkscreen printmaking, I would have to be able to duplicate the look and feel of the popular mediums of expression. Oil paintings, watercolor, gouache, pastel, and charcoal were among the mediums that I had replicated in silkscreen ink. Through careful application of the stencils and by printing the ink consistently with the specific look and feel of the density of a heavy brush stroke or the lack of build-up, as in a watercolor wash, or the thin but graphic quality of a pencil stroke, I was able to produce each medium's subtle qualities.

 In my zeal to formalize and replicate the look and feel of oil painting, I learned that any effect that I could visually break down to lines and dots could be cut in silkscreen film as stencils. By brushing into the edges of the stencil with slowed and thinned lacquer-based silkscreen filler, I found a way to give my prints the look of traditional brushed mediums. One of my most stylistic developments is my perfection of the scumble technique. Those were the days and nights of continuous experimentation. With the artist's satisfaction comes definite satisfaction with the completion of a job well done.

---

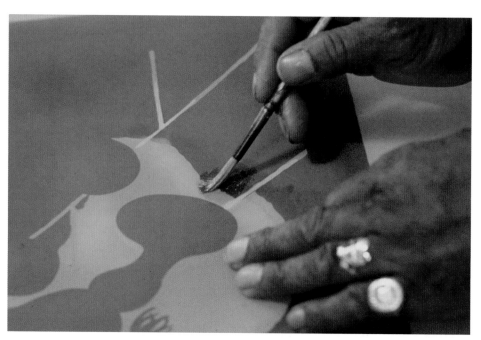
Lou Stovall showing the brushed stencil technique, 1975.

Over the years I made my own work, and I also collaborated with other artists to make prints with them or for them. As a collaborative printmaker, when I approach a work of art that is to become a silkscreen print, I look very carefully to determine my capability and the depth of my interest. Whether it is my own work or that of another artist, I examine the range of probabilities with the knowledge that I can indeed interpret the work into the silkscreen medium. It is simply a matter of time, materials, and my personal commitment.

Collaboration can also begin from scratch, simply with the artist's desire to make a new and wonderful work. From forty years of working together and my many collaborations with Sam Gilliam, which are important to me, I took many lessons. He is one of the few artists who could work quickly and surely enough to invent an interesting format on the spot and then come up with ideas for each subsequent color on demand. Printing in this manner requires total attention to the image as it progresses, as well as to the image the artist hopes to accomplish. My responsibility is to show what is possible, to have a willing attitude to experiment, and to clean the screen as many times as necessary in readiness for the next image.

My inclinations to stand and see, to look and wonder, and to write and draw are counterpoints, each supporting the other. I believe if one seeks to understand the wonder of a waterfall, it is helpful to stand still to watch the water, to hear the sounds, and to feel the. Such observations hold expectancy of thoughtful action. At times the act of making art fuels an idea and energizes its theme, but most often the action of making art sustains my desire to write. Once my motivation is in motion, my thoughts are not confined to the single work before me. Instead, the desire to sing, dance, and compose verse adds to the fullness of my creative experience.

Sam Gilliam and Lou Stovall, *Dance 72* poster, silkscreen print, 1972.

At the height of creativity, I am both performer and audience. The act of making art is like a stage production. I desire to make my whole self available to all of the possibilities of personal creativity, essentially applying Descartes's philosophy, "I think, therefore I am." My need to be a visual artist is as persistent as my desire to express myself in words. From these thoughts I could only think back to the admonition of my father when I told him as a child that I wanted to be an artist: "Well, you had better be a good one." The thought of being a good artist is forever with me. I look forward to my older years when I will sit beside a window looking deep into some imaginary forest, making images in my mind.

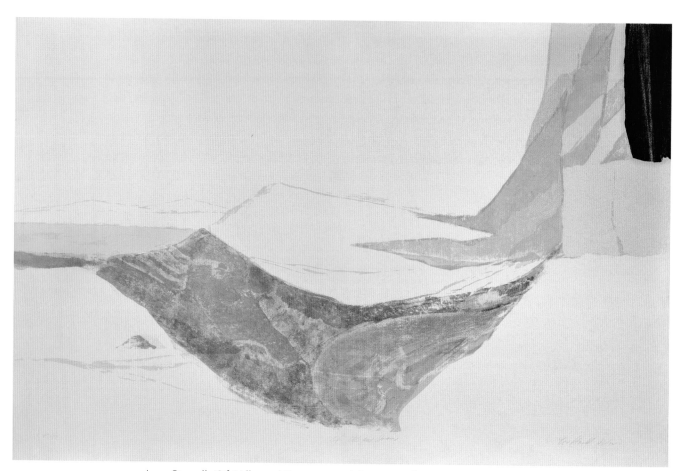

Lou Stovall, *Of Hills and Streams and Passing*, silkscreen print, 1972.

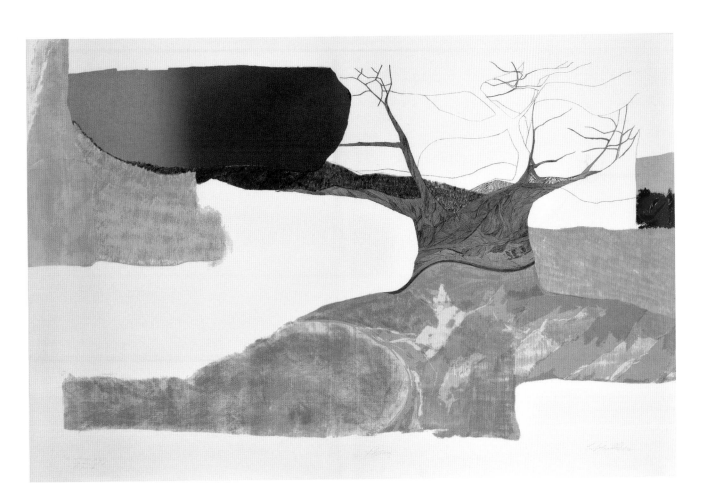

# ACKNOWLEDGMENTS

This publication has its origin on Father's Day, 2018, when my father and I went to a Sunday afternoon discussion of Maurice Jackson's book *DC Jazz*, also published by Georgetown University Press. After the talk, Maurice told me, "Lou Stovall needs a book, and Georgetown should be the publisher!" Thank you, Maurice, dearly, for your great belief and for making it possible.

And thank you Hope LeGro, Alison Snyder, E. Ethelbert Miller, Ray Barker, Kathleen Cahill, and John Woo.

—WILL STOVALL

# ABOUT LOU STOVALL

Lou Stovall was born in Athens, Georgia, and grew up in Springfield, Massachusetts. He studied at the Rhode Island School of Design and earned his BFA from Howard University, where he was a student of James A. Porter, James Lesesne Wells, and David Driskell. Since 1962 he has lived and worked in Washington, DC. Stovall's drawings and silkscreen prints have been supported by grants from the National Endowment for the Arts, and he has been recognized as a chief innovator in the medium of silkscreen.

In 1968 Stovall started Workshop Inc., a small, active silkscreen workshop focused primarily on printing community posters. Under Stovall's leadership, Workshop Inc. evolved into an internationally respected printmaking studio. Stovall has worked with artists such as Jacob Lawrence, Sam Gilliam, Elizabeth Catlett, Robert Mangold, and others. Stovall's own prints and drawings are part of numerous public and private collections throughout the world.

# ABOUT THE EDITOR

Will Stovall is an artist and painter who has also worked in the book medium. He holds a PhD from Yale University with a dissertation on the institutional imagination of philosopher Jürgen Habermas. He lives in Washington, DC.